Design Basics

for Creative Results

line type shape texture balance contrast unity value color lin
e type shape texture balance contrast unity value color line t
ype shape texture balance contrast unity value color line type
shape texture balance contrast unity value color line type sha
pe texture balance contrast unity value color line type shape
texture balance contrast unity value color line type shape tex
ture balance contrast unity value color line type shape textur
e balance contrast unity line type shape texture balance cont
rast unity value color line type shape texture balance contras
t unity value color line type shape texture balance contrast u
nity value color line type shape texture balance contrast unit
y value color line type shape texture balance contrast unity v
alue color line type shape texture balance contrast unity valu
e color line type shape texture balance contrast unity value c
olor line type shape texture balance contrast unity line type s
hape texture balance contrast unity value color line type shap
e texture balance contrast unity value color line type shape t
exture balance contrast unity value color line type shape text
ure balance contrast unity value color line type shape texture
balance contrast unity value color line type shape texture bal
ance contrast unity value color line type shape texture balanc
e contrast unity value color line type shape texture balance c
ontrast unity line type shape texture balance contrast unity v
alue color line type shape texture balance contrast unity valu
e color line type shape texture balance contrast unity value c
olor line type shape texture balance contrast unity value colo
r line type shape texture balance contrast unity value color li
ne type shape texture balance contrast unity value color line
type shape texture balance contrast unity value color line typ
e shape texture balance contrast unity value color line type
shape texture balance contrast unity value color line type sha
pe texture balance contrast unity value color line type shape
texture balance contrast unity value color line type shape te

Bryan L. Peterson

Design Basics
for Creative Results

HOW
DESIGN BOOKS

Cincinnati, Ohio
www.howdesign.com

About the Author

Bryan L. Peterson is president and founder of Peterson & Company, an eight-person design firm located in Dallas, Texas. Peterson & Company was founded in 1985 and is recognized nationally for achievements in corporate and college visual communications.

Peterson's work has also appeared in numerous national design publications, including *HOW Magazine, Communication Arts,* American Institute of Graphic Arts Annual, *Graphis,* New York Art Director's Annual, Print Regional Design Annual, *American Illustration* and the Type Directors Club Typography Annual.

Peterson is a 1979 graduate of Brigham Young University where he received a BFA in graphic design. He began his design career as a member of the publication teams at Brigham Young University and Southern Methodist University, and in 1993, he attended the BYU Homecoming festivities as the Honored Alum of the Year for the College of Fine Arts and Communications.

In 1992, Peterson was selected to judge the prestigious 33rd *Communications Arts* design annual competition. In 1986, C.A.S.E. (Council for Advancement and Support of Education) named Peterson "National Designer of the Year."

Peterson's artistic talents take on another form in the musical arena. As well as playing piano with the all-designer retro-rock band The Fabulous Fuzztones, Peterson wrote, performed and produced a solo CD, which won recognition for its design in various competitions. He will soon release his second musical album.

Design Basics for Creative Results, **Revised Edition.** Copyright © 2003 by Bryan Peterson. Manufactured in China. All rights reserved. No other part of this book may be reproduced in any form or by any electronic or mechanical means including information storage and retrieval systems without permission in writing from the publisher, except by a reviewer, who may quote brief passages in a review. Published by HOW Design Books, an imprint of F&W Publications, Inc., 4700 East Galbraith Road, Cincinnati, Ohio 45236. (800) 289-0963. First edition.

07 06 05 04 03 5 4 3 2 1

A catalog record for this book is available from the U.S. Library of Congress

Designer: Bryan L. Peterson
Art Director: Lisa Buchanan
Editor: Amy Schell
Production Coordinator: Michelle Ruberg
Page Layout Artist: Camille Ideis
Photographer: Christine Polomsky
Page 14: image © Scott Morgan/Getty Images
Page 22: image © Don Farrall/Getty Images
Page 80: image © Marco Prozzo/Getty Images

The credits on page 141 constitute an extension of this copyright page.

Acknowledgments

 Admittedly, writing a design book that is expected to give readers a solid foundation for working in the graphic design field is a tall order. To establish yourself as a viable design professional, much more is necessary than simply reading a how-to book. A collaboration of forces—mentors, professional opportunities and experience—is necessary to fully arm you, the reader, with a working knowledge of graphic design. But it is my hope that by helping you to understand the design elements contained herein, this book will allow you to become fascinated with the creative possibilities this profession has to offer.

No undertaking such as this is done adequately without the help of many people. I am grateful to F&W Publications and HOW Design Books for the promotion and marketing of this second edition of my book. I always enjoy working with the editors and art directors within that company. Special thanks go to Clare Warmke, Amy Schell and Lisa Buchanan for their patience and determination to have this book succeed.

These pages contain real-life examples of great design, created by some of the most talented designers from across the nation. Obviously, this book would have much less of an impact without their rich contributions. This is a wonderful profession; I love being a graphic designer and feel fortunate to be associated with these friends and professional peers. I also acknowledge my co-workers at Peterson & Company for their support and contribution. I am lucky to work daily with such fine and creatively talented people.

Finally, I wish to express gratitude to my wife, Valerie, and to all our children. They give me perspective on what is really important in this life, and subsequently bring joy and inspiration to mine on a daily basis.

And as for you, the reader, I hope this book exceeds your expectations. Along with helping to teach you the basics of design, I hope it communicates the joy and satisfaction that come with being involved in any creative venture.

Table of Contents

*Learn how to balance creative and
practical considerations so you
can choose the best format for your
design—every time.*

*Line, type, shape and texture are
the building blocks for any
design. Learn how (and when)
to use each of these elements
to create great designs.*

*Here are some principles of design
structure that will help you
create strong designs that not only
hold up, but also stand out in
a crowd.*

(before you begin)

Can good graphic design be taught? The ability to develop a clever concept or idea—the heart of all great design—is difficult to teach, since it relies largely on the life experiences and innate abilities of the designer. Once an idea is born, however, the skill of effectively translating this idea to a visual design—executing the concept—can indeed be taught. Many good ideas have fallen on the sword of poor execution. This book will help you to maximize the power of your good idea by using sound principles to translate that idea into a strong and organized visual communication.

Introduction

Always Begin with a Good Idea

Why do you need a good concept or idea? Without it, your design is basically decoration. But coming up with a great idea is not about design itself. It is that spark you get when you feel the design that portrays this idea could ultimately communicate something clever to the viewer. It might be a twist on a cliché or the coming together of two unrelated elements which gives them new meaning. For example, a revolver with the barrel replaced by a cigarette would communicate the idea that smoking is deadly. The same revolver with a flower protruding from the barrel would carry an entirely different meaning. What would that visual mean to you?

How to Generate an Idea

First, you must completely understand the problem. Ask your client questions and listen carefully to the answers. If you are designing a piece where the copy has already been written, read it. At this stage, don't be concerned about solutions. I once heard a quote from an unknown author that illustrates this point: "Give me a problem and I will give you a solution. Give me a solution and I've got problems." It's too early to be concerned about solutions when you're just beginning to generate an idea.

Anything you can do to understand the client's business and the intent behind the piece you're designing is time well spent. This fact-gathering stage will give you a perspective on what you are trying to achieve with your design. Without it, you will likely be off-target or misdirected and risk ending up with a design that is weak in concept. Then you might be inclined to try to save your design with decoration.

After you have a solid understanding of the objective you are to achieve with your design, let the idea incubate for a period of time. This may be long or short, depending on the demands of the schedule. But force yourself to roll the problem around in your mind while doing other things. I believe that intense concentration is the enemy of inspiration. Sometimes the best solutions come when my mind is partly somewhere else: when I'm doing activities like driving a car, taking a shower or going for a walk. Great ideas come when you least expect them. But make sure to keep the problem in the forefront of your mind; otherwise, the chances of the solution coming unexpectedly are slim.

When Do I Know the Idea is Right?

You've heard it said that your first idea is often your best idea. At times, I've found this to be true. But I never stop with my first idea. I believe I owe it to my client and myself to continue to generate ideas—if for no other reason than to test the strength of that first idea. If the first idea is weak, sometimes I am required to go through several trite concepts before my mind finds the sophistication to generate a concept that hits the nail on the head.

When generating ideas, draw on your personal experiences. They are yours and yours alone and will make your design unlike any other. Be careful to make sure your idea is not so obscure as to not be understood by your audience. The best ideas are those that produce envy—you think "I wish I'd come up with that." The best ideas are so good that you think surely they should have been thought of before.

Be careful not to put more than one idea into your design. Two ideas in the same design don't make the design twice as good. In fact, each of the ideas diminishes and usually conflicts with the clarity of the other.

Generating Ideas on the Computer

I became convinced years ago that the best concepts come to me when I am not required to make any analytical design decisions. For this reason I recommend you

not create concepts using a computer. My theory is that the computer, as wonderful as it is, is largely a tool for executing an already existing idea. As soon as we sit in front of our monitors we are required to make decisions about such things as document dimensions, typestyles, font sizes, weights of lines, etc. All of these decisions are analytical and have little to do with improving the core idea. Consequently, by starting the process of creating an idea on the computer, it is not unusual for the creation of the idea to take a back seat to mechanical considerations.

Instead, I begin the design process with a sketchpad and pencil—or by simply thinking about the problem I intend to solve with nothing to impede the pure idea. Or I make simple line drawings that are boiled down to a basic concept. Once I feel the idea is strong then I will move to execute—visually interpret—that idea using the principles outlined in this book.

So first, focus on generating a good concept…and then pick up this book. Even when you have a good idea, it can easily be buried under sloppy execution.

How This Book Works

In this book, you'll get an introduction to design basics—an explanation of design elements and principles to help you master the art of visual organization and structure. Each of these elements and principles is explained verbally as well as visually. Along with the demonstrations defining each element and principle, exercises are included so you can actively learn how each design element works. Don't shortchange yourself by skipping these exercises; doing them can give you a much clearer understanding of the text. At the end of each subsection is a list of important questions to help you summarize the material you have studied in that particular section. Ask yourself these questions to test your comprehension of the material.

The other component of each chapter is examples of these design principles in action. As you learn the organizational skills, real-life examples will show you how these principles are put into action in actual projects.

Even when you have a good idea, it can easily be buried under sloppy execution.

Poor use of the basic design principles will impede communication of even the best concept; these same design principles, when used skillfully, will allow the idea to rise to the surface. The goal of this book is to teach graphic designers how to use basic design principles to convey solid concepts in their designs.

While I purposely chose work that predominantly displays the use of one particular element or principle, it's a rare work that exclusively demonstrates a single element or principle. For example, while a design may show use of line as the primary means of communication, there will most likely be other ele-

All designs begin with an area of nothing but space—an empty canvas without color, type, lines, shapes, photographs or illustrations.

ments used as well, and of course these elements are applied using the basic design principles. Hopefully you will be able to see how the skilled designer uses the very principles outlined in the chapter to create great visual design that has impact.

And while you probably know much of this information intuitively—if a design feels unbalanced, for instance, you might know something's wrong with your design, but not know why—being able to identify why something doesn't work is your first step toward making it work better. And your first step toward getting creative results in your work.

While this book alone will not turn you into an expert designer, the lessons taught can establish a foundation that will stay with you throughout your design career. Don't be discouraged if you occasionally forget these principles or struggle with some of the concepts. Even as I wrote this book, it was a great help for me to review the very principles that I use and have applied daily in my profession over the past twenty-five years; you too may need to review these concepts often to gain a full appreciation of them.

Best of luck to you as you embark on a creative and rewarding journey toward understanding the power of graphic design.

Format Comes First

The page is blank; where do you start?

All designs begin with an area of nothing but space—an empty canvas without color, type, lines, shapes, photographs or illustrations. This space is usually defined, especially in layout, by a perimeter dimension. We'll call this defined space format. If you are baking a cake, for instance, you first determine what kind of cake you hope to end up with: cupcakes, a single-layer cake or a traditional two-layer cake. This desired result determines what kind of cake mold you'll use. Selecting the correct mold before you raise a single spoon to add an ingredient is critical to achieving your goal.

In the same way, your first task before beginning any design is to decide the size and shape of your format. In some cases the format will be predetermined, but when the choice of format is up to you, there will be two specific considerations:

Creative Formatting

What visual impact do you want to have on the viewer and what format would best accomplish this? Sometimes the size of the piece can be the most important creative decision you make. My firm designed a sixteen page issue of *Rough* magazine (the monthly publi-

cation of the Dallas Society of Visual Communications), that was not bound by staples but instead, folded out to become a 22" × 34" (55.9 × 86.4 cm) poster-like newsletter. Our intent was to create an impact on designers who too often are required to keep designs to standard dimensions. On the other hand, if we had felt that this project required a classic, sophisticated feel, we might have used a booklet format instead.

Sometimes the shape of a format increases the visual impact of a design. For example, a brochure in the shape of a circle will stand out from the sea of rectangular brochures. If it is a brochure promoting a basketball team, even better: the format reflects the content. Much of what we do with design creates an immediate impression on the viewer before even a single word is read; format plays a large role in creating the proper mood for a design.

in your budget for paper and printing? All these practical considerations will affect your choice of format.

When the format of a piece is considered carefully from both these viewpoints, your design is well on the way to being appropriate for the client. It also is beginning to become a design solution that carries a visual impact.

Elements Are the Ingredients

In the example of the cake, what ingredients do you intend to use?

Once the dimensions are established, you'll begin to gather the elements that will be used to compose the design. Just like baking a cake, all of the ingredients must be at your disposal to create the finished piece. If you're missing the flour, you may end up with some-

Good design structure is a result of correct use of principles.

Practical Formatting

Will the final printed piece be mailed in a particular size envelope or need to meet specific weight and size restrictions set by the post office? Will it eventually need to fit a folder, a binder or some other filing system? If the design is for a poster, what are the posting restrictions, where will the poster hang or what size tube will be required for mailing? How much money do you have

thing—but it won't be a cake! Likewise, you'll find it very difficult to design anything that is initially missing one of a few essential ingredients. We'll refer to these visual ingredients as design elements.

The Four Primary Design Elements

Line. One of the simplest of all the elements, a line is a great organizer. It can be used to decorate, to create a

mood, and to connect or divide other elements for better communication.

Type. The written word has been used throughout the ages to communicate. When translated into a type style, it takes on an added visual personality and gains power as an element of communication.

Shape. Shape is often incorporated in the form of photographs or other types of art. Shape may consist of a block of color or value that adds cohesiveness to a design; lines of type can form a visual block of text that may also be perceived visually as a shape.

Texture. Just as the tactile nature of building materials is of great importance in creating the mood of a structure, visual texture is important in conveying the design message. Texture can cover the format—such as the effect achieved by using a particular style of paper— or be used selectively in conjunction with another element to enhance the personality of the design.

Each element is covered in greater detail in chapter two in preparation for building a design. A design can use one or all of these elements, depending on the message (both verbal and aesthetic) that your piece needs to communicate; without these elements, a design is no more than a blank format.

Structure Is the Recipe

Exactly how long do you bake your cake and at what temperature do you bake it?

Once a baker has all the ingredients that will go into his creation, the exact order and process used to combine the ingredients will determine the actual success of the finished cake. The baker may elect to frost a half-baked sheet cake, and the cake's physical appearance may even deceive the viewer, but the first slice into it will bring a stark reminder that things were done out of order or steps in the process were not adequately completed.

Likewise, a design will be weakened by the improper organization of elements. The organization of elements in design is called structure. The principles of design, which are further covered in chapter three, are the bylaws of proper structure. Good design structure is a result of correct use of principles.

The Four Primary Design Principles

Balance. A design can create a mood simply by feeling organized and evenly balanced. Sometimes a design can benefit from purposely appearing unbalanced.

Contrast. Use of contrasting elements is a key to designing with impact. Extremes give a design interest and keep it from being static. Through careful use of contrast, a designer can add interest and even emphasize the message.

Unity. Unity is the skillful placement of elements within your design to create order or to make a statement. Several different elements—from lines to type to shapes—can be assembled to create a unified or orderly look that helps the design to feel visually organized. The formal application of a unified structure to a format is sometimes called a grid.

Value and color. Both value and color can be powerful communicators of mood. They can also provide order to a design and emphasize important elements.

These principles, which are covered in chapter three, allow you to plan and evaluate the arrangement of elements in your design.

Format

a format is any surface on which the elements that will be used to build a design are placed; structure, on the other hand, is the way these elements are placed in that format.

Sometimes format decisions will be already made for you. If you're designing a letterhead, you'll likely need to fit a standard envelope size to avoid the expense of a custom-envelope conversion. If you're designing a magazine, you'll usually need to work with a predetermined size and shape that were chosen with weight, printing and ease of mailing in mind. When designing a direct-mail piece, you'll almost always need to include a direct-response mechanism such as a business-reply card or return envelope—both of which must comply with postal regulations.

But when you don't have these kinds of rigid constraints, the possible shapes and sizes of a format can provide a dizzying array of choices. For example, if you are designing a book about postage stamps, should it be a multipaged book small in size to reflect the size of a stamp or a large poster with hundreds of stamps placed side by side? Or how about using die cuts so the edges reflect the perforated edges of a stamp? In these cases, you can focus on the creative requirements of the design (keeping any practical requirements in mind) to determine which format is the best for your project.

Good design can often be made great by the skillful use of a creative format. Make this decision carefully as you begin your design, and you will often find the rest of the design falls automatically into place.

Format

If you're designing a billboard, you'll be required to work with the size and specifications provided by the billboard manufacturer. If you're asked to create a T-shirt, your format has also been predetermined. (However, your design may likely have to fit the various sizes of T-shirts.) But for those cases where you'll be the one to decide on the format, you'll need to balance a variety of considerations—both creative and practical.

Creative Considerations

Once again, the idea behind your design will drive the need for a specific format. Never forget the idea when beginning to work with the size and shape of your piece. The most important factor in deciding the size and shape of your format is the effect you want your design to have on its audience. Whenever your choice of format is unrestricted, this should be your primary consideration. For instance, have you ever struggled to open a foldout road map while sitting behind the wheel of your car? The experience could lead you to decide there must be a better format for maps used in confined spaces. Many years ago I purchased a map that was spiral bound; this map is so easy to use that I am able to refer to it while traveling in traffic. The format is right for its use and for the audience.

Speaking of mood, an oversized brochure may give a design a feeling of luxury or grandeur, while an undersized piece often communicates delicacy or evokes a precious quality. For a younger audience, the shape of the piece may be key. Many children's books are whimsically cut out in the shape of a character in the book or otherwise formatted to hold the attention of a very young audience. For a poster illustrating bridges, for example, a long, horizontal format would add excitement and allow better depiction of the subject matter.

Especially in the beginning, let your imagination run wild. There will be plenty of opportunities for rational thinking as you further qualify the chosen size of the piece on the basis of price, filing needs and other practical considerations. But start your planning with the intent to use the format as a creative boost to your design. Let the sky be the limit. Do what you think will have the most impact on your audience; don't compromise your vision before you even start designing. And don't automatically assume that your client or audience will prefer the standard solution. Often they are just as bored with the usual approach as you are and might willingly entertain something not so expected.

Practical Considerations

Once you've considered what format will work the best aesthetically for your project, you must review more practical considerations, all of which must be balanced in determining what format you decide on.

Quantity of information. Consider the amount of text and art that you need to incorporate into your piece. Often when I design a piece that will utilize both text and art (photos, illustrations, white space, etc.), I establish a ratio. That is, I consider the audience and intent of the piece, then decide that there ought to be, say, 30 percent text to 70 per-

cent art. I run the copy into a grid of my intended format that is set up to represent this ratio. I can immediately see whether or not the text and art projections match up with reality. If they don't match up, it may be necessary to adjust my format to accommodate the text/art requirements.

Ask yourself these questions before making a final decision. What will be most likely to get the reader interested in what you've designed? Will the amount of material fit into the format you want to use? Being tricky for tricky's sake seldom works in effective communication; your format should instead be determined by your message and by the amount of information you have to communicate.

Final quantity and print production. Paper is usually milled to certain sizes and shipped directly to the printer. Papers for web presses usually come in a continuous roll that will fit the in-line stitchers and binders and that will result in the least paper waste when running standard-size printed material, often 8⅜" × 10⅞" (21.3 × 27.6 cm) or some derivative thereof.

Sheet-fed presses employ paper in three standard sizes: 23" × 35" (58.4 × 88.9 cm), 25" × 38" (63.5 × 96.5 cm) and 26" × 40" (66.0 × 101.6 cm). Other sizes are available upon request, but will usually result in a surcharge. Like the

web papers, sheet-fed papers are purposely cut to accommodate standard printing sizes, most often 8½" × 11" (21.6 × 27.9 cm). This generally works well for designers, since the majority of typical pieces will fit these paper sizes with minimal paper waste.

The illustration at bottom left shows how well an 8½" × 11" (21.6 × 27.9 cm) page will fit on the 23" × 35" (58.4 × 88.9 cm) sheet; you'll be able to fit eight sheets of 8½" × 11" (21.6 × 27.9 cm) paper on one 23" × 35" (58.4 × 88.9 cm) sheet with very little paper waste. If you designed your piece to be 9" × 12" (22.9 × 30.5 cm) instead, you would be required to move to a larger sheet of paper, 25" × 38" (63.5 × 96.5 cm), that would cost slightly more per sheet. If the print run of the piece is substantial, you will have to decide if your budget can stand the bigger sheet of paper. This kind of practical thinking is crucial in the process of deciding size of format. If the print run is substantial and, consequently, the cost of paper is a major factor, I will determine my design format by figuring how my intended size will "cut out" of the sheet of paper. I may want to design a piece that is 13" (33.0 cm) square but realize that 13" (33.0 cm) will not allow me to print more than four single pages (front and back) on each full sheet of paper.

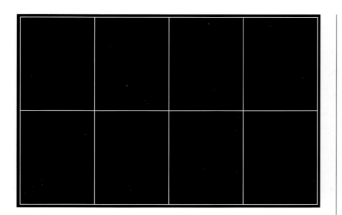

An 8½" × 11" (21.6 × 27.9 cm) page will fit eight times on a standard press sheet of 23" × 35" (58.4 × 88.9 cm), with very little waste. If your design called for a 9" × 12" (22.9 × 30.5 cm) page, you would need to move to the next-larger press sheet for printing.

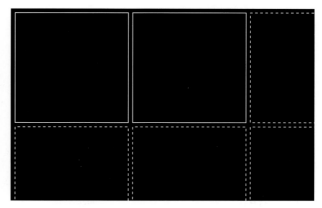

A design that's 13" (33.0 cm) square will fit only twice on a standard press sheet of 23" × 35" (58.4 × 88.9 cm). If paper cost is an important consideration, you may be limited to choosing a more standard page size for your piece.

In order to get two pages to fit on the 25" (63.5 cm) side of a 25" × 38" (63.5 cm × 96.5 cm) sheet of paper, the brochure must be no taller than 12½" (31.8 cm). But in reality, you also must leave room for the gripper, which is the device that clamps onto the paper and pulls it through the press, and a little room between the pages, since the brochure may have bleed (a brochure that bleeds is one where the ink goes all the way to the trim). Taking into account ½" (1.3 cm) for the gripper and ½" (1.3 cm) between the two pages and from the edge of the page to the edge of the sheet (a total of 1½" (3.8 cm)), your brochure can be a maximum width and height of 11¾" (29.8 cm). That is: ½" + 11¾" + ½" + 11¾" + ½" = 25" (1.3 + 29.8 + 1.3 + 29.8 + 1.3 = 63.5 cm). See the illustration below.

On the 38" (96.5 cm) side of the sheet, allowing ½" (1.3 cm) between each page and on each end of the sheet, you would be able to fit three pages with ¾" (1.9 cm) left over. For example, ½" + 11¾" + ½" + 11¾" + ½" + 11¾" + ½" = 37¼" (1.3 + 29.8 + 1.3 + 29.8 + 1.3 + 29.8 + 1.3 = 94.6 cm).

If paper cost is a factor, the key is to find a way to adjust the size of the piece to allow for the least amount of waste. Sometimes you can find a use for the unused trimmed-off portions of the sheet, such as using the paper to print additional materials (many designers use these trimmed-off portions to print their self-promotion pieces—with their clients' permission, of course). Even printing a smaller-size piece on the sheet with the original piece can result in a cost savings overall. However, this can sometimes complicate the printing process and should be done only with the approval of your printer.

Cost of mailing. Postage rates are based primarily on trim size and weight. As the designer, you'll need to find out what your client's postage budget is for the piece, and then keep that in mind while designing. One way of doing this is to keep an inexpensive postal scale in your office to weigh paper dummies of annual reports and other projects. As you work, you can verify that the trim size (and, if applicable, length) and the paper weight you've chosen—considered in conjunction with the print run—won't cause you to exceed your client's postage budget.

The weight and quality of paper you choose will also affect this cost. Paper is typically milled in several basic weights: 70, 80 and 100-lb. book and text weights, and 65, 80 and 100-lb. cover weights. Paper is calibrated in thicknesses measured in terms of the weight of the paper. The heavier the weight of the paper, the thicker the paper. Other weights are milled for specialty papers. Moving your text weight to a heavier weight can cause mailing costs to jump to a more expensive category, pushing your postage costs up substantially.

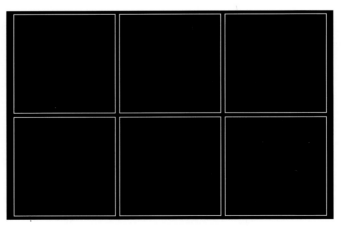

You will often need a little room between pages, and will always need room at the edges of each press sheet (where the gripper handles the sheet). Six pages, each 11¾" (29.8 cm) square, will fit nicely on a press sheet of 25" × 38" (63.5 × 96.5 cm).

Paper is also made in different grades: A "premium" paper is considered to be the best, followed by number 1, 2, 3 (and so on) grades. The smaller the number, the finer the sheet. The higher the grade, the whiter the sheet and the better it will print. Accepting a lower grade paper will reduce the paper costs—while often not significantly influencing the printability of the sheet. Increasing the trim size of a piece, which increases the amount of paper used for each page, will also increase the bulk of the piece—again increasing postage costs.

While you might be able to build a convincing case that the aesthetics of a project justify an increase in the postage budget, the cost of mailing should be considered when making your final decision on format.

Final destination. Ask yourself how the target audience will use the final piece. Will it be filed in a folder for future reference, placed on a coffee table, hung on a wall,

away before it's even opened. A poster that is too big to post in limited wall space will not get posted at all; however, a poster that is too small will not attract enough attention among the competing posters on the wall.

Balancing Creative and Practical Considerations

Through experience, you will eventually gain an ability to balance your creative wishes with the realities of cost and practicality. I would suggest you choose a paper manufacturer and ask one of their sales representatives to show you the different grades of paper along with the cost per thousand sheets of each. When specifying a paper for an actual print job, you can also have the sales representative give you an idea of how much paper will be required and what the incremental costs will be for adjusting grade, size and

> The message of a project is enhanced when it is skillfully placed in an appropriate format; a message that is placed in the wrong format for its audience loses power.

or thrown away after the reply card is torn off and returned? Part of effective communication is to make the greatest possible impact with your design and to persuade your audience to use the piece for as long as possible.

An annual report with an awkward size or shape might have more impact in the hands of shareholders and analysts who handle numerous annual reports on a daily basis, but it might make it difficult for them to file away. An illustrator's self-promotion brochure that doesn't fit in an art director's file cabinet will not likely be around when that art director is hiring an illustrator. On the other hand, a direct-mail piece with a typical size and format may not attract the necessary attention among the myriad of other direct-mail pieces, and may get thrown

weight. With experience, you will find these considerations becoming second nature, and your client will be impressed with your intention to use just the right paper specification to get the job done for the right cost.

An Appropriate Format Enhances Any Design

The message of a project is enhanced when it is skillfully placed in an appropriate format; a message that is placed in the wrong format for its audience loses power. Remember that the format is the canvas upon which you paint; determining the right nature and size of canvas is critical to the outcome of the final painting.

What to Consider When Determining a Format

1 *What visual impact do you hope this piece will have on the intended audience?*

2 *How much information will you eventually be expected to place on the format? Does the quantity of type or quality of art dictate that you use a certain proportion?*

3 *How many pieces will be printed? How will the desired format print on standard paper sheet sizes?*

4 *How will the format impact the cost of mailing? Will using a smaller size or a different format give you a break on mailing costs?*

5 *What is the end use of the piece? For example, does it need to fit into a particular file folder or be placed in an existing sales kit?*

6 *What is the visual function of the piece? Will it work better as a multi-page brochure or if it's folded in a certain way?*

E X E R C I S E

EXPLORING FORMAT

The Manifold Possibilities

When you begin to choose a format for your design, let your imagination be your guide. Even a piece that has a finished size of 8½″ × 11″ (21.6 × 27.9 cm) can be coaxed into a variety of formats. The illustration at right shows a typical 8½″ × 11″ (21.6 × 27.9 cm) page in just a few of the format possibilities; imagine what you could do if there were no restrictions.

Take a piece of paper and experiment with various folds. Although you would rarely begin an actual project with an 8½″ × 11″ (21.6 × 27.9 cm) piece of paper and fold it to a smaller size, this exercise will allow you to explore ways of folding a sheet that may surprise you. Don't give up after trying the most obvious solutions; force yourself to be original. What can you do with other size sheets? Try this same experiment with sheets that are larger, such as 8½″ × 14″ (21.6 × 35.6 cm) (legal size), or smaller (even a business card may contain a fold).

However, you may discover that most projects don't require an odd fold. This is fortunate, since generally the more intricate your fold, the more expensive the piece. One reason is that an intricate fold will require an intricate die to allow the fold to fit standard stitching and trimming equipment. In addition, anything out of the range of a

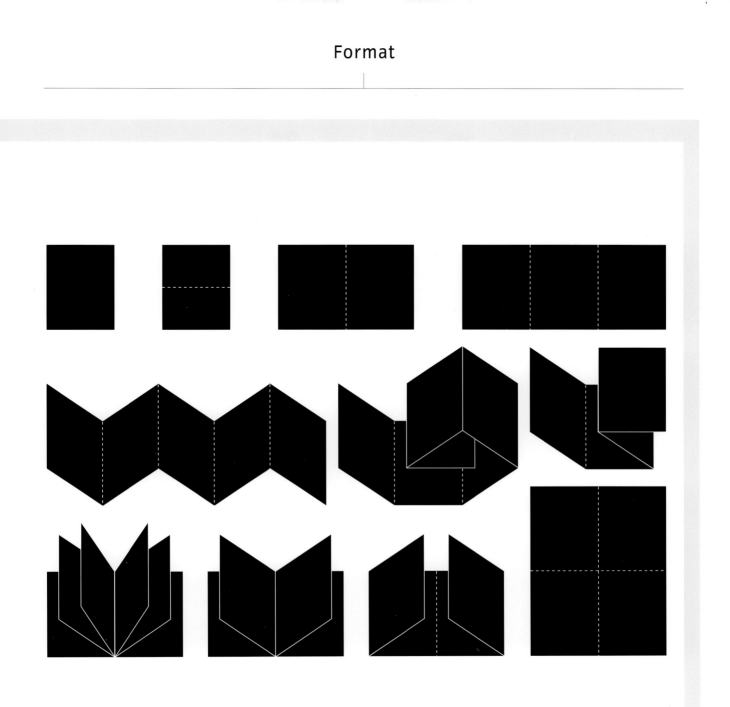

Here are just some of the format possibilities you can consider when designing pieces with a finished size of 8½″ × 11″ (21.6 × 27.9 cm).

standard folding machine may cause your project to require hand-folding—which, depending on the quantity and complexity of your job, could substantially increase the cost and add time to the production schedule. Knowing when a unique idea merits the extra cost it entails, and when it does not, is a skill you will build as you gain experience as a designer.

Elements

think of the design process as taking the shape of a diamond. You begin the process at the top of the diamond with the nucleus of an idea you desire to communicate to your audience. At this point you have only the idea you generated, with no thought given to execution. As you proceed down the sides of the diamond, you add in elements—line, shape, type and texture—utilizing basic design principles that will help you best communicate this idea. (These basic principles are the subject of chapter three.) You reach the midpoint of the diamond when you have added every possible element that could aid communication of that original idea.

Then you begin to dispense with elements that are unnecessary to the pure idea or weaker than other elements chosen. Finally, you choose to use only those elements you judge to be crucial to conveying your idea, at which time you will have reached the other point of the diamond.

Just as any physical object can be broken down into basic molecules, every design consists of one or more of the four basic elements: line, type, shape and texture. Organized line has the power to direct the eye. The legibility and "feel" of a typeface convey meanings of their own, regardless of the content of the text. The shape of a picture (or pictures) on a page can be just as important as the content of the photo. And texture is always present, even when it consists of nothing more than the tactile feel of the paper. All parts of any design can be classified as one of these four basic elements, despite the almost limitless variety within an element.

Knowing which elements to include or exclude, which are necessary and which add unnecessary clutter or dilute the power of your idea, will strengthen your design ability, and you will soon develop an intuitive gauge to test which elements are crucial to a specific design. Remember, the best designs contain the fewest elements necessary to communicate the idea.

Line

In chapter one, we established that, much as a painter must first choose the size of his canvas, a designer must first determine the appropriate format for a particular project. Once you've made this decision, you can begin to gather the elements that will, in the end, be used to construct a design. Your goal should be to use as few of the appropriate elements as necessary to communicate your idea with the greatest power.

Let's begin with the simplest of these elements: line. With a single stroke of a pencil (or a computer mouse) you can call this element into play. You can then manipulate the mood of your design or organize your page, depending on the kind of line you've drawn and its placement on your format.

Lines Can Have Infinite Variety

At their most basic, lines (or rules) can add strength to an idea or communicate a feeling. Lines that are fat or thin, long or short, curved or straight, sharp or fuzzy, composed of dots or dashes, or with squared-off or rounded corners each have distinct personalities that will bring a unique flavor to each piece in which they're used. Look at the illustrations to find several different kinds of lines.

Use Line to Create a Mood

Once you've picked the type of line or lines you'll use, shaping and placing them is equally important in creating a mood. Look at the lines illustrated on the next page. In example A, the simple horizontal line placed centrally in the format feels comfortable and calm surrounded by white space; when that same line is placed off-center and at an angle, as in example B, a more active feeling is suggested. Horizontal lines typically communicate a restful feeling, while vertical lines denote organized activity (as in example C) and angular lines can add tension and random action to a design. A curved line, like virtually every

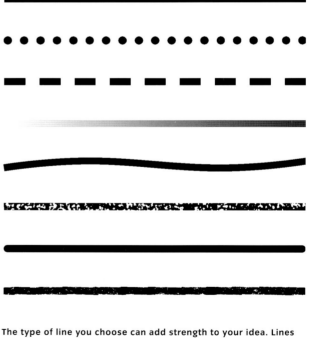

The type of line you choose can add strength to your idea. Lines can be fat or thin, long or short, curved or straight, sharp or fuzzy, or even composed of dots or dashes.

line, can be used to establish direction, but in addition it gives the design a flowing or moving feel (as in example D).

Who can't appreciate the beauty of soft rounded hills in a pastoral landscape? Contrast that with the hard angular feel of mountains jutting from the ground. Line is responsible for the mood of these two contrasting natural settings. A dashed line on a road indicates the proper lane divisions; this dashed line also indicates permission to pass another vehicle, while a solid line prohibits passing. With the same example in mind, white lines often separate the road from the shoulder, providing a safe place to stop in an emergency. As you start to appreciate the importance of line, you can't help but notice the parts lines play in our everyday lives. As an exercise, spend one hour of your day outside the home simply noticing line, both man-made and natural, and how it affects your life.

Use Line as an Organizer

When used appropriately, line is a powerful element that can be employed not only for communication, but also for organization. Most road signs are linear by nature. In design, lines can be used on a page either to join related elements or to divide unrelated ones. As an exercise, open a copy of your favorite magazine and notice how often lines are used in this way. For instance, notice how they're used to join an article and an accompanying photograph in a box. Also notice how often lines are used to frame a photograph, separating it from the type or other graphics surrounding it, or to separate a sidebar from the rest of a page.

Borders—which are nothing more than lines organized around shapes—also qualify as organizational tools, even when they're used to line an entire page. The cover of *National Geographic*, for example, uses a wide yellow border. This border is really just a line effectively used for identification and power; in fact, the logo or identity of the magazine is defined by its simple yellow borderlines.

Line is the best friend of a grid. Grids are created on the format to add order and give the designer a designated position for type, shapes, textures or other lines. Often type is placed in organized columns on the page to cue the reader to the flow of the text. To strengthen this grid, actual grid lines are sometimes drawn to designate columns or position of art. As a bonus, when these grid lines appear throughout a brochure or magazine, the piece is given a rhythm that adds structure and unity to the design.

Use Line to Add Texture

Especially in illustration, line can be effective in adding texture to your artwork. Take a look at the poster by Lanny Sommese on page 34. Notice how the entire poster is made up of lines—even the background texture is established through the use of line in the type. The feeling of this particular line—hand drawn with a pen in a loose style—also lends a specific feel to the poster. Imagine how different this poster would look if the lines were rigid and controlled.

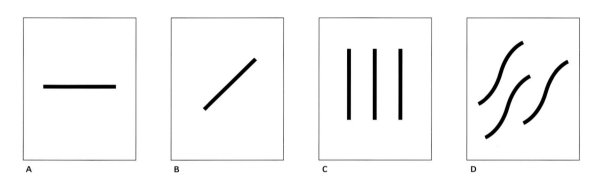

A B C D

In example A, the placement of the line creates a calm mood. While B shows the same line, its position and placement suggest a more active feeling. The lines in C suggest organized activity, while the curved lines in D give a flowing feel.

What to Consider
When Using Line

1 *Have you chosen lines that convey an appropriate mood or strengthen your idea in some way? Have you given thought to the full array of possible types of line you might use (thick vs. thin, sharp vs. fuzzy, wavy vs. straight)?*

2 *How do the lines you have chosen organize your design? Are you using line to connect or separate other elements on the page? Do these lines actually lead the eye in the ways you intend? Have you thought of using a border as a design element?*

3 *Are you able to use lines to establish a grid? That is, are lines used to support columns of type or photographs, and do these lines appear in the same position from page to page, giving your design structure and unity? (An underlying grid can be quite valuable, even if the grid lines themselves are invisible in the design.)*

4 *Does your use of line create texture in your design or illustration? Does this texture reinforce your idea?*

5 *Are you using line wisely? Are there lines in your design that are freeloading on the design—not performing a service of any kind? (Remember the diamond example and remove any lines from your design that are not contributing to your idea; unnecessary lines will serve only to clutter your design and distract from your idea.)*

EXPLORING
LINE

Cutting the Diamond

The ability to distill a design to its most powerful form using simple elements is a key to successful design.

In the introduction to this chapter we compared the design process to the shape of a diamond. You begin with only an idea—the top point of the diamond—then expand into a wider and wider shape

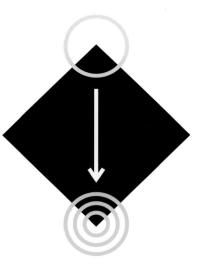

Think of the design process as diamond-shaped. You start with an idea, add in all the elements you can think of to express that idea, then narrow your focus and eliminate all but the strongest elements to create your finished design.

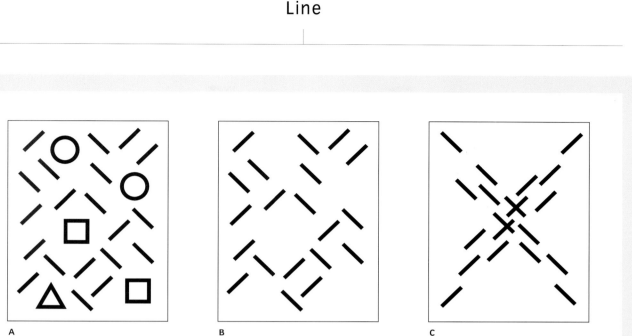

A B C

How would you illustrate a gathering? First, add all the elements you can think of that help convey the idea (example A). Then, begin to eliminate elements you don't need (example B). Finally, keep (and arrange) the minimum number of elements you need to convey your idea (example C).

as you add all possible elements for expressing that idea. Finally, you begin to eliminate weaker elements and to narrow your focus once again until your design is composed only of the strongest elements that convey the original idea.

For example, suppose you're trying to illustrate the idea of a "gathering" using simple elements such as lines, type, shapes and textures. Begin by asking yourself if you want to communicate this idea with just a few simple lines or if you'll need to add type, shapes or textures to communicate the concept effectively. You may want to start with lines only; you could decide to start out with type, shapes or any other element.

Add elements to the format until you feel that all possibilities have been explored. At this point, your design may seem cluttered with lines, shapes and so on. You have effectively reached the midpoint of the diamond shape, having added and considered every possible element that could strengthen the idea. Now try removing one type of element, such as all the shapes. Did doing this weaken or strengthen the idea? In this case, you might decide that the shapes you've introduced only confuse the concept and that

the idea of a gathering can be communicated with the use of only a few strategically placed lines.

What if you remove lines? How many lines are necessary to communicate the idea? Can the idea of a gathering be communicated using only a few strategically placed lines? When do you seem to have one line too many?

Since a gathering must involve at least several pieces, and should include the concept of "coming together," you may decide that you could use as many as thirty lines to give direction to the gathering and a feeling for the idea. But could you illustrate the idea with just twenty lines? Follow this process until you have only the minimum number of lines, shapes, type or textures you need to communicate the idea most strongly. The finished design in the example above consists of twenty strategically placed lines that effectively communicate "gathering." You also find yourself at the bottom of the diamond, having eliminated all but the elements necessary to the design.

As you eliminate elements, you travel down the diamond shape to the end point where the idea is strongest and communicated with just the right kind and number of elements.

Line

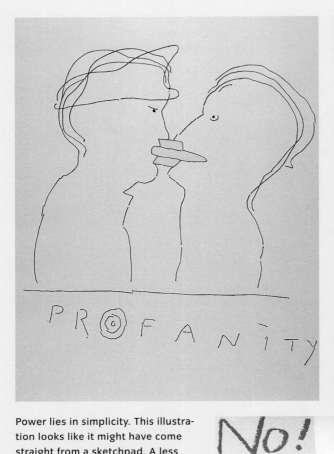

Once again, the quality of the line used in this design never changes from the type to the illustration. The lines are easy and free flowing, and the design needs no more information than what is provided to effectively communicate the idea. The yellow missile going from one mouth to the other leads the eye immediately to the subject of the poster, profanity. The human forms need no more than the minimal detail to let the viewer know that the subjects are two people without gender (this smart decision makes the design more universal, as well). The only humanizing feature in the faces of the figures is the emotion in their eyes, which enhances the concept by portraying the idea of perpetrator and victim. The slanted type reflects the unsettling nature of the illustration and is complete with the substitution of a bulls-eye for the *O*.

Profanity Poster
Lanny Sommese
Sommese Design

Power lies in simplicity. This illustration looks like it might have come straight from a sketchpad. A less sophisticated designer might have decided that this image was too rough and may have been tempted to embellish it with solid color or produce it as a refined hard-edged illustration. But the very cryptic nature of the art is what gives it power. The red delineation of the missile superimposed on the jet adds impact to the idea and reinforces the threatening nature of the drawing. Finally, putting the illustration on an angle implies that this active missile is zeroed in on its intended target. As for type, the emphatic exclamation, "No!" is all that needs to be said. The phrase takes an already strong concept and adds emotion and voice to it. The whole illustration makes exceptional use of line in an understated manner, so the power of the statement can be heard.

NO! Poster
Lanny Sommese
Sommese Design

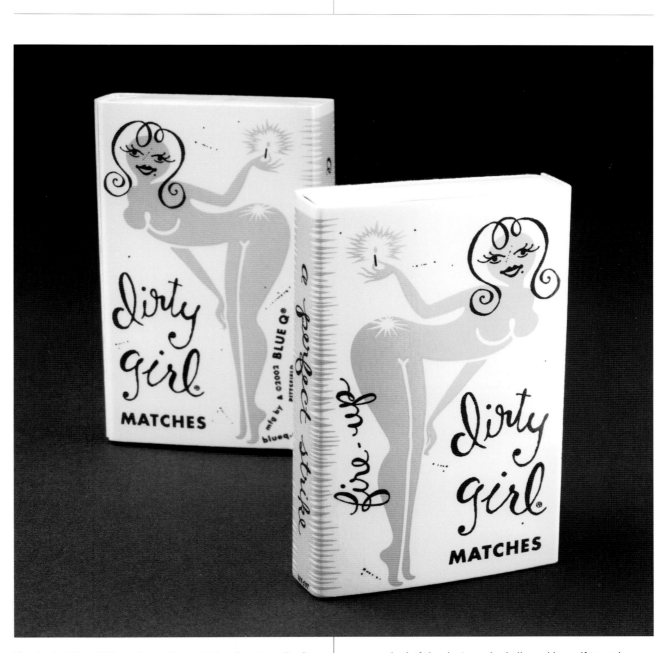

The femininity of this package design is the direct result of line quality and color treatment. The curvilinear nature of the lines in the illustration—along with those in the type— gives this design a natural whimsy. The type is hand-lettered and is rendered to purposely imitate the quality of line used in the illustration. It is also interesting how the designer chose to keep this package primarily two-color. Along with being more economical to print, it is also exactly what is needed to provide the right look. Notice how the type is not overworked. If the designer had allowed herself to make more refinements to the type, the less effective it would likely be. There is a certain delight in the haphazard nature of the design that gives it a favorable innocence. Knowing when to stop refining a design is as important as knowing what to refine.

Dirty Girl Matches Packaging

Haley Johnson

Haley Johnson Design Co.

Line

This poster shows how just a few strokes of line can be used to effectively illustrate a swan. While the lines do not adhere to the anatomy of a swan, the image is unmistakable, and the simplicity and grace of the lines convey a feeling of tranquility. There are no excess lines; the poster has just the number of lines needed to communicate the image. Particularly successful is the use of wavy lines to communicate a reflection on the water. Type is used sparingly, and only to provide needed information to the viewer. There are also several powerful principles at work in this poster. One is contrast: the lines are printed in silver ink on a predominantly black background, which gives the lines a shimmery quality and adds to the elegance of the design. The same silver on a white background would not have nearly as much drama. In fact, the blend of color as the swan meets the water actually gives the poster dimension, even though the swan is drawn as a two-dimensional figure using flat graphics. Also notice how the moon and type serve as elements of balance. The wavy lines are centered exactly at the bottom of the poster, and the moon and type, along with the swan's head, counterbalance the silver lines as they veer to the right on the upper half of the poster.

Swan Poster

McRay Magleby

Magleby and Company

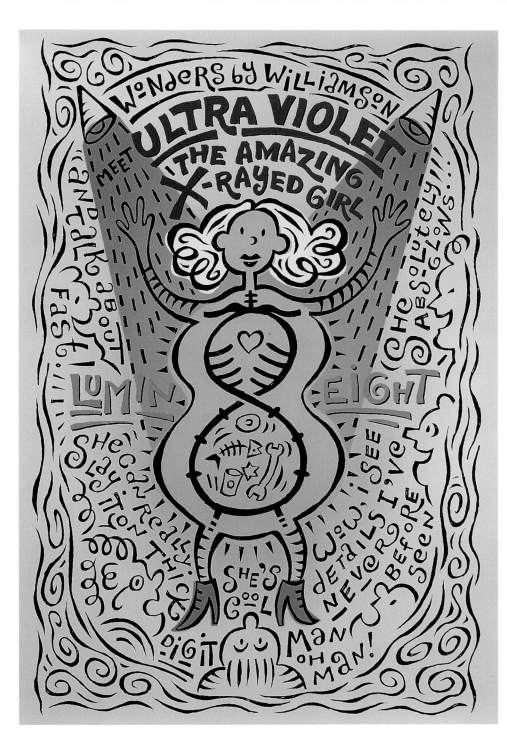

The intent of this poster was to focus attention on a new printing process called Lumineight that was being offered by a printing company. This poster is printed using that process. The actual illustration was done on a 5″ × 7″ (12.7 × 17.8 cm) piece of paper with a black ballpoint pen and enlarged to fill the poster size. By enlarging the image, the line takes on a rough quality. Refinement of the line quality would work against the rough spontaneous look that the illustration embraces. The type in the illustration mimics the look of the drawing and is, in parts, hidden within the drawing. To go with an actual typeface would have been a mistake since the feel of the poster dictates that the type stay in character with the feel of the illustration. While the drawing takes on a freeform style, the poster feels basically symmetrical. Remember that symmetry is an implied balance of elements, not a literal mirror image of two perfectly equal sides.

Williamson Printing Poster
Bryan Peterson
Peterson & Company

It's difficult to attempt an analysis of this poster with regard to how it uses any single design element or principle, since it uses so many aspects of design effectively. Certainly, without the lines in the water, the image would lack depth and movement. On the other hand, there is clearly a use of line to give shape to the ocean, and this shape is central in the poster's design. Given the concept, it isn't necessary for the type to be any more complicated than it is. It's interesting that the poster feels balanced, even though it does not possess perfect symmetry. The orange in the lower sky effectively balances the whiteness of the wave. Since the wave is moving to the right, it is placed to the left of center to visually balance the design. What really carries the poster is a very powerful idea.

Peace Poster
McRay Magleby
Magleby and Company

While some of the posters we've displayed to this point uti-
lize a rough line, this poster was drawn to feel very clean
and crisp. Notice the different feel that this poster communi-
cates in contrast to some of the previous examples. The line
quality you choose can make all the difference in the mood
of the design. Notice how the same line drawing that
appears in black is enlarged, ghosted back and placed
behind the black line illustration to add dimension and inter-
est to the design. That interest is further enhanced by divid-
ing the format into four equal quadrants and assigning a
different color to each one. This simple but effective use of
line and color makes a very simple line drawing come to life.

Music Poster
McRay Magleby
Magleby and Company

The mood for this commemorative poster is set by one sim-
ple stroke of the brush: the viewer can instantly see a snow-
capped mountain. With the placement of three small circles
above the year 2002, an implied Olympic symbol comes into
view. Once again, the most straightforward approach carries
the impact of the design and simplicity wins over needless
complexity. As uncomplicated as the design is, the addition
of five saturated colors to the rings gives the design addi-
tional interest. Also important to this design is the selection
of the type font. Anything other than a simple sans serif font
would be too much against the simplicity of the line illustra-
tion. It is also imperative that the font provide a round zero
instead of an oval or other shape since the zero needs to imi-
tate the Olympic rings.

Olympic Mountain Poster
McRay Magleby
Magleby and Company

Every line in this poster design is the same weight except for the perimeter borderline. This provides an instant unity to the poster by automatically linking the hand-drawn type with the illustration. Along with an execution that uses respectable restraint, this poster starts with a great idea. The world, which is the focus of the illustration, represents unrest and trouble. The easy chair, on the other hand, is a common symbol of rest and relaxation: typically when we relax in an easy chair we are not burdened by the troubles around us. Part of the comfortable feeling the poster conveys is due to the way the type is handled. Not only is it hand-drawn, but it is allowed to arc playfully across the full width of the poster, unrestrained by any design element other than a rule. The rules not only divide the lines of type, but serves to organize the design.

What's the Matter Poster
Lanny Sommese
Sommese Design

This handsome series of ads is a testament to the effectiveness of simple line. In fact, every line in every ad is based on the original logo in some form. All of the line weights are adaptations of the logo used in some playful fashion to communicate a variety of messages. The challenge of this series is that it requires the designer to be especially creative so the different ads have variety and are able to hold viewer interest. This kind of campaign is commonly referred to as an image awareness campaign. It serves to make the logo identifiable to the public and establishes a brand identity for the company. The color palette is necessarily limited to keep the color scheme simple.

Oracle Mobile Poster Series
Brian Gunderson
Templin Brink Design

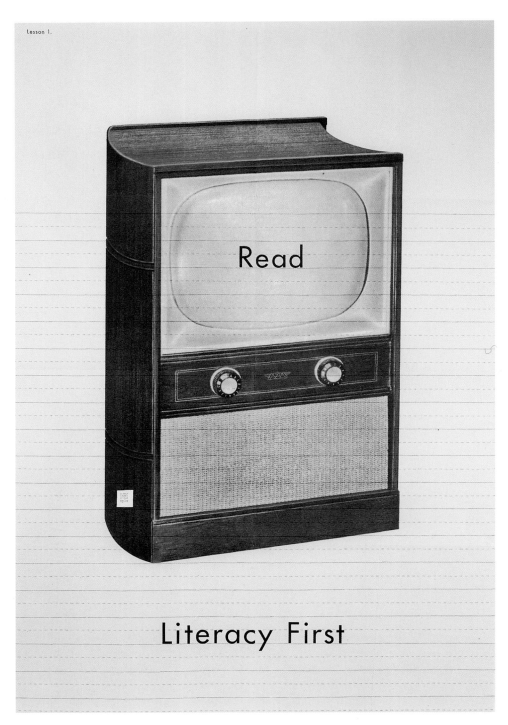

Lesson 1.

Read

Literacy First

I liked this example of line because the simple handwriting guides make the poster concept work. The designer could have decided to leave it off and let the concept come through the illustration, but the handwriting guidelines on the school paper add the finishing touch to the poster. They also give the headlines *Read* and *Literacy First* a resting place and a purpose for their position. I also like the fact that the designer allowed the blue guidelines to pass over the illustration instead of "knocking them out" or placing them behind the illustration. This lends the design a cohesiveness that might not have been as strong had the designer elected to go the other way with this decision. Concepts need not be tricky to be effective. Simple things like the addition of these lines to the design can often make the difference between a good design and great design.

Literacy First Poster

Haley Johnson

Haley Johnson Design Co.

Type

type is a crucial element for any design in which it appears—and it is used in most graphic designs. Type is perceived by the viewer in several ways simultaneously: as text to read, as shape, and as a purely visual element in which the letterforms themselves convey a feeling or a meaning. Consequently, learning to use type well is one of the most important skills you can develop as a graphic designer. In fact, when looking at a portfolio for the first time, I immediately take notice of the candidate's use of type. What fonts have been used and do they reflect good taste? There are many fonts on the market which stretch the boundaries of good taste. Are the fonts selected appropriate to the concept of the design? Is the type too large, or so small you can't read it? Is the leading—the space between the lines of type—appropriate? Is the space allotted between the individual characters of type (tracking or kerning) correct?

Using type well means using it appropriately to communicate, taking into consideration the various ways it will be perceived by the viewer. When you've used the character of a visual symbol—the typeface itself—to convey the meaning of the written word, you've effectively used type to solve a problem. When type is used well, it may even stand alone—without any accompanying illustration or photograph. Some of the best designs are simple type solutions.

When type is used poorly, however, it is difficult to look beyond it, as it often interferes with the intended message.

Type Can Create a Mood

Let's look first at a single character of type to understand the power type can give your design. When set in various faces, even a single letter—such as a lowercase *a*—can evoke different feelings, depending on the design of the typeface. When the letterform is flowing and curvaceous, the feeling conveyed is softer than the feeling communicated when the letterform is angular and hard-edged. A whimsical letterform will convey a lighthearted mood; one that is elegant will communicate sophistication.

As another example, choose two words with contrasting or even opposite meanings, such as *peace* and *war*. After seeing each of these words in the various typefaces (see next page), which face do you think is most appropriate to the meaning of each word?

While the Helvetica typeface on the top is adequate to communicate either idea, the words take on added meaning when set in a script such as Snell Roundhand, or a bold, square, sans serif typestyle such as Machine. Notice how jarring a completely inappropriate typeface can be.

Even a single character of type can evoke different feelings, depending on the design of the typeface in which it's set.

Often, two or more contrasting typefaces can be used compatibly in the same design. In fact, interest is generated by the use of contrasting typefaces such as the elegance of a Goudy Oldstyle font with the stark blackness of a Univers Bold or Black. In a magazine layout, for example, a serif face can be used in conjunction with a sans serif face—one for body copy and the other for sidebars, captions or headlines.

Type Has Many Variations

Typefaces are typically divided into four categories: serif, sans serif, display and script.

Serif faces get their name because the characters have short lines or serifs stemming from the upper and lower ends of the strokes of a letter, causing some of the letters to resemble the serif of an architectural column. (Consider an uppercase *I* set in Times Roman, for example.) And they are usually considered to be classical fonts because they have been around since the early days of hot metal type. Serif faces are most commonly used for body text because they are very legible. However, you should still select the font that is most appropriate for the idea of your design.

Sans serif faces lack serifs, thus the name (*sans* is derived from the Latin *sine*, or *without*). Sans serif faces were especially popular in Swiss design because of their simplicity and straightforwardness; they generally have a more modern feel than serif faces. Sans serif faces are used for many kinds of text, and are often used for headlines or captions because they tend to stand out more than serif fonts.

Display faces derive their name from early-1900s advertising when a particular face was needed for a headline only to "display" a product. The idea of using a dis-

peace war

peace war

peace war

Choice of typeface depends, in part, on the content of the text. While the Helvetica typeface on the top is adequate to communicate either idea, notice how the words take on an added meaning when set in an appropriate typeface. (Also notice how jarring an inappropriate typeface can be.)

play face in body copy was unthinkable—and is still inappropriate in most cases—because these faces tend to be very ornate. They are made to run larger and may lose integrity when reduced to body copy size.

Script faces are derived from penned calligraphy and are most commonly used to convey elegance and sophistication. A plethora of script faces exist; you will often see them used on such elegant correspondence as wedding invitations.

Typeface choices in all of these categories are plentiful.

When choosing a typestyle for your design, keep in mind that one of the most important virtues to possess is restraint. Some typefaces are simply too decorative for most purposes, and while you might believe you are enhancing communication when you choose one of them, you may be unnecessarily complicating your design. Some typestyles have ornate caps that were meant to be set only in conjunction with lowercase letterforms.

I recently visited a very upscale hotel in Orlando, Florida where the signage was done all in uppercase with a font that was never designed for that purpose. Consequently, there were flourishes of one letterform colliding with flourishes of another, which seriously reduced the readability of the signage and resulted in a poor visual presentation. That seemingly small type decision had a major effect on the way-finding signage and overall visual presentation of the hotel.

In the example on the bottom of the page, you might at first have expected a more decorative face to be the better choice, but note how a simpler typeface can often communicate with greater power.

The computer has also given the typographer the option to distort the type horizontally and vertically, or to attach an effect, such as dimension, blurring, outlining or any number of other distortions, to the type. I believe the use of these distortions should be rare, judicious and respectful of the inherent design of the letterform. Inappropriate distortions distract the viewer and appear gimmicky. Most of these classic type fonts have been with us for some time and have been refined over the generations to create the best effect. On occasion, skilled use of distortion may be appropriate, depending on the feel of the design.

In the example at the right, the distortion of the type is what makes the idea work.

In this example the distortion of the type makes the idea work, but inappropriate distortions can distract the viewer and appear gimmicky.

Choose an Appropriate Type Size and Font

Once you understand the power of a single character of type and how the choice of typeface can be a powerful influence, you're ready to use type as a design element. There are no hard-and-fast rules for how large or small your type should be in the format; generally speaking, common sense will dictate font size.

THERE IS NO EXCELLENT BEAUTY THAT HATH NOT SOME STRANGENESS IN THE PROPORTION

THERE IS NO
EXCELLENT BEAUTY
THAT HATH NOT SOME
STRANGENESS
IN THE PROPORTION

Some typefaces are simply too decorative for most purposes. At first glance, you might think a decorative face would be a good choice for this sentiment, but notice how the simpler typeface is actually more powerful.

Consider the audience and the nature of the project. Type that is too small may be bothersome to read. Type that is too large may overpower the other elements or take away sophistication or elegance. If you are designing a booklet that includes technical data, form will follow function; an easy-to-read typestyle set in an easy-to-read size is required. If you are designing a poster that has a single word as a message, such as *death*, and you want the poster to shock the viewer, you may want to use a very bold face and a large typestyle to achieve a bold effect. But if, on the other hand, the idea is to communicate the sacredness of death, you might want to choose an altogether different face.

The example below shows how the same word set in two different typefaces can communicate two different messages. Notice also how the additional use of line strengthens the concept in each design.

Type Can Be Used to Create Shapes

When many words are used together in the text, you'll have an additional aspect of the type to deal with. A grouping of text type is often called body copy because it begins to take on a shape in addition to the given form of each letter or word. The example below illustrates how the same body copy can have a different effect depending on the typestyle, type size and configuration of the text.

The skilled designer has a feel for how large or small type should appear for a particular design. Black type that is set small will give the appearance of being a massive gray shape on the page. This may be desirable if the goal is to relieve the eye from an otherwise busy design. But more often, this gray mass of type is unattractive to the reader and may make the design feel ominous.

The same word, when set in two different typefaces, conveys two different messages. Unlike the example on page 38, using the words *war* and *peace*, either of these faces might be appropriate, depending on what aspects of death you want to communicate.

Type Can Be Timeless or Trendy

Remember that every character of every typeface was at one time designed and crafted by a designer. Many faces are classic and have been refined continuously over the centuries; the best of the old faces have stood the test of time because of their usability and readability.

Other, more faddish faces (often display—or decorative—typefaces) were designed to achieve a certain effect. For instance, Blippo was designed in the 1960s and was quite popular, but today is considered to be a face that caters to the fads of that time; you may be able to use Blippo when designing a "retro" piece—for instance, a poster for a venue featuring music from the 1960s—but you would never use it for body copy in a textbook. Caslon, on the other hand, has been around for over a century and continues to be popular today because of its classic style.

In other words, there are both timeless and trendy typefaces. Only through experience and trial and error can you build a palette of typefaces that not only will provide any feeling you wish to communicate in your design, but will stand the test of time. You will also find you can eliminate from your palette those faces that hinder communication.

Your tastes will constantly evolve over time. Don't be dismayed if a typeface that you currently feel is useful becomes useless to you in years to come. This is a result not only of a change in fads but also a refinement of your own tastes.

What to Consider When Using Type

1 *What typestyle will best communicate the feeling of your message? Does your typeface harmonize with or detract from your message?*

2 *Will two or more different typestyles be more effective in displaying the concept than one? (Consider combining a serif face with a sans serif face, for example.)*

3 *What size type will best convey the idea of the design? Is the size appropriate for the audience? Does it complement the other elements?*

4 *Is the type properly placed in the format to have the most impact on the reader? Are the shapes of the body copy pleasing or are they unattractive?*

5 *Is the typeface one that needs to hold up well over a period of time, or is a more current typeface a better choice?*

Type Can Be Timeless or Trendy

Type Can Be Timeless or Trendy

The typeface used on the left will probably look current fifty years from now, while the typeface on the right will risk having a dated feel.

EXERCISE

EXPLORING TYPE

Secrets of Kerning (Tracking)

Proper spacing of the characters in typeset words is ultimately the responsibility of a competent designer. Type in body copy is not normally custom-spaced by the designer, since most page layout computer programs (or other typesetting equipment) automatically set up pleasing spacing. Even still, you can adjust the tracking—the space between the letters—to appear loose or tight depending on the desired effect. But when using larger type—such as in a headline—it is often necessary to individually adjust the space between letters; this is known as kerning the type. It's especially important in certain combinations where letters don't automatically fit together well—such as a capital *L* followed by a capital *A* (see below).

Over the years, I've heard of several methods that can be used to achieve pleasing letter spacing; following are two that have worked well for me.

1. The sand method. Imagine that you are going to pour an equal amount of sand between every two characters of type. The bigger the initial gap there is between two characters, the closer they will have to be moved together to accommodate the same amount of sand. For example, an uppercase *C* and an uppercase *X* would create a sizable gap between the two letters. Conversely, if you have two characters that fit together snugly, such as an *I* and an *H*, you may have to separate them a little to accommodate the same amount of sand. In certain extreme cases, such as when an *L* is placed next to an *A*, a ligature may be required; this is where the left serif of the *A* will overlap the *L* to close up the space.

2. Three-letter method. Look at only three letters at a time of the word you wish to space, and ignore, for the moment, the rest of the characters. For example, in the illustration below you would view only the characters *l*, *e* and *t* of the word letter. When these three letters look evenly spaced, next view only the characters *e*, *t* and *t*. Then, space the letters *t*, *t* and *e*, and so on.

letter spacing
letter spacing

LAND

letter spacing
let
let
ett
ett

Good letter spacing can make a big difference, as this "before and after" sample shows (top). And below, sometimes a very large space between letters can be best closed by a ligature.

One way to approach letter spacing is the three-letter method. By looking at a word just three letters at a time, you can focus your attention on small parts of the word in turn, until all of the letters are pleasingly spaced.

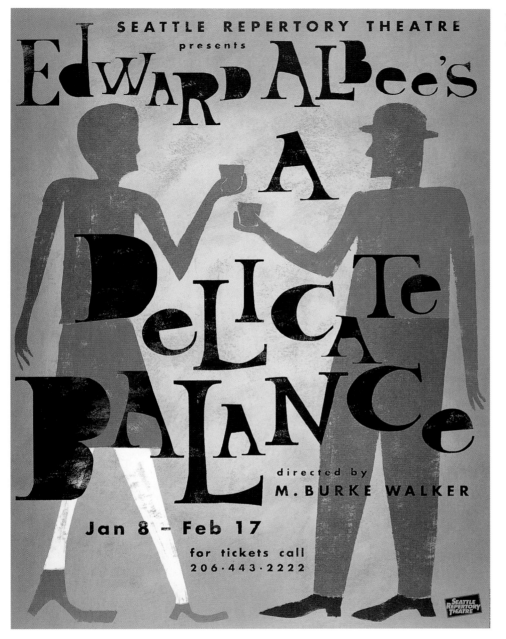

A Delicate Balance Poster

Dennis Clouse

Cyclone Design

The type treatment on this theater poster makes it memorable. This piece is working on so many levels—it has great color, balance and texture—but the hand-lettered type really provides the spark. In the design process there was likely a decision about whether or not to use a standard font or hand lettering. What makes this use of type so successful is that it is a combination of both. The hand lettering is based on an actual font but modified to be appropriate to the design. The designer made two other good decisions. One was to allow the texture of the illustration to seep through into the type. Notice how beautiful the *B* in the word *balance* is. The other was to fill in some of the letters in the headline, thus adding even more interest to the design. While the headline font is based on a serif font, the smaller type is based on a sans serif font. This contrast of fonts allows each of the type choices to occupy its own space within the design. In other words, the contrasting of two font styles in a design is often key to making the type compatible.

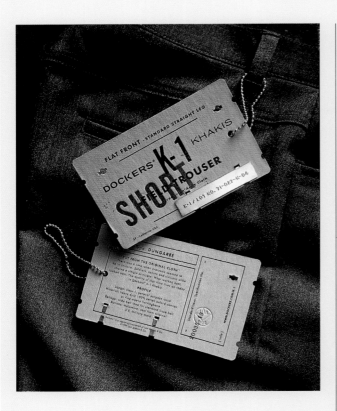

This clothing tag design breaks most of the rules of traditional tag design. The type is daring. For instance, notice how the simulated stamped word *short* is printed right over the *field trouser* identifier. More conservative clothiers would shy away from impeding any readability in the design. But this infraction adds a freshness and vitality to the design that can be achieved only by such type treatment. Along with the daring type, the tag uses engraving, embossing, die cuts and a metal label attachment to add to the mood and sophistication of the product. Such attention to detail and a spare-no-expense attitude does wonders to elevate the buyer's perception of the product. Notice that while all the type is sans serif, there are several fonts applied and different facings within each font. Also notice that the condensed type lends a wonderful contrast to the extended fonts.

Dockers K-1 Tags

Gaby Brink, Jason Schulte

Templin Brink Design

These posters take the unique approach of combining art and type into one image. While very simple in design, they effectively attract the eye. All of the important information is used to outline the shape of the head in each design. Hands and arms are added to give the idea that the speakers are being assembled. Only one color of ink is necessary to complete the designs. Restraint is so important in any design, but especially this one. Remember: don't allow yourself to add anything except what is critical to the core design idea. This could include color or other elements that ultimately serve only to distract from the original concept of the art. The designer elected to use a sans serif font since the design demanded clean lines and uncomplicated letterforms. Serifs always add an element of complication to a letterform because they are inherently more active. This is often desirable; but in this case, it is not.

Speaker Posters

Lanny Sommese

Sommese Design

This photographer's promotional brochure uses type to reinforce the concepts of the photographs on each spread. In many cases, the type is even used to add definition to the image it's displayed with. You've heard that a picture is worth a thousand words; here you see how just a few printed words can expand the meaning of a photograph. The cover of the piece uses typographic and visual images from various pages in the brochure. Notice how the type pages are printed in two basic colors: the backgrounds are always light green, while the type and graphic elements are printed in either dark green or black. These relatively subtle colors function as neutrals; when these pages are placed next to multicolored photographs, they tend to emphasize the color in the photos without detracting from or clashing with them. In the center of the book the design employs a black bar on the photo side placed next to a green bar on the type side. This simple element ensures that there is always a buffer between the type and the photo.

Robb Debenport Photography Brochure
Bryan Peterson
Peterson & Company

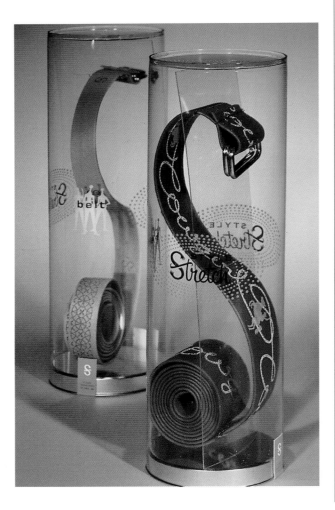

If the foremost intent of a retail design is to attract the eye of the shopper, then this handsome package works on many levels. Notice how the product itself imitates the letterform S. What better representation of the Style Stretch name could there be? Not only is the product intriguing by its very nature, but the package design works so well because it is primarily typographic in nature. Notice the contrast in typestyles between the words *style* and *stretch*. This is another example where contrasting the two fonts makes them compatible. To choose styles that are too similar might cause them to conflict. In this case, attaching the sans serif extended font to the much more whimsical script font of the product name works well.

Style Stretch Package
Sharon Werner
Werner Design Werks, Inc.

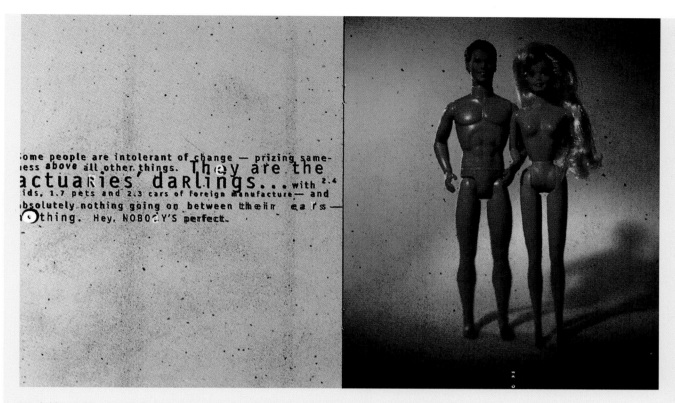

ome people are intolerant of change — prizing same-
iess above all other things. They are the
actuaries' darlings...with 2.4
ids, 1.7 pets and 2.3 cars of foreign manufacture— and
ibsolutely nothing going on between their ears —
othing. Hey, NOBODY'S perfect.

Much like the brochure on the previous page, this brochure places type and photo images on opposite pages. Although the type receives a similar treatment on each page, and is in roughly the same position on most pages, the brochure maintains a high level of interest through the subject matter of the photos and the unconventional treatment of the type. The type is over-lapped, given a drop shadow, modified in size and color, and highlighted with an opaque white ink on different paper colors. Notice how the type is placed almost against the left and right trim of the piece. While at first glance this violates a rule of design by not giving the type a large enough margin, this treatment is very effective in adding to the tension that the type is trying to communicate. This is a good example of how rules are meant to be broken—but only in the name of strengthening the concept.

Intolerance Brochure
Steve Pattee and Kelly Stiles
Pattee Design

Type

I included this simple paper promotion because it's carried successfully by a single idea that's expressed almost exclusively through type. The purpose of the piece is to promote a Crane business paper called A6, and the use of A6 in every major word in the piece is a great way to visually reinforce the name of the paper. The A6 type is separated from the other letters by the use of red for these two characters throughout. The type is always placed in the same position on every page. Other nice touches include the use of engraved type throughout and the placement of an embossed rectangle on the cover of the brochure. This design is elegant and unembellished, proof that the simplest design is often the most powerful. Try to take every element you can out of your design until it carries only the essence of the idea.

Crane A6 Paper Promotion
Eric Madsen
The Office of Eric Madsen

This playful cover is for *Rough* magazine, the Dallas Society of Visual Communications club newsletter. Different design firms take turns designing monthly issues of the newsletter. The design for this issue uses the letters in the word *rough* to create a visual statement. Based on a square-serif font, the letterforms themselves challenge the reader to assemble the word rough. The effect is to attract the eye to a design that does not immediately make sense and have the reader "discover" the type. Beyond the configuration of five letterforms that make up the word, the background is treated with similar shapes that serve to make the design more interesting.

Rough Cover #4
Jan Wilson
Peterson & Company

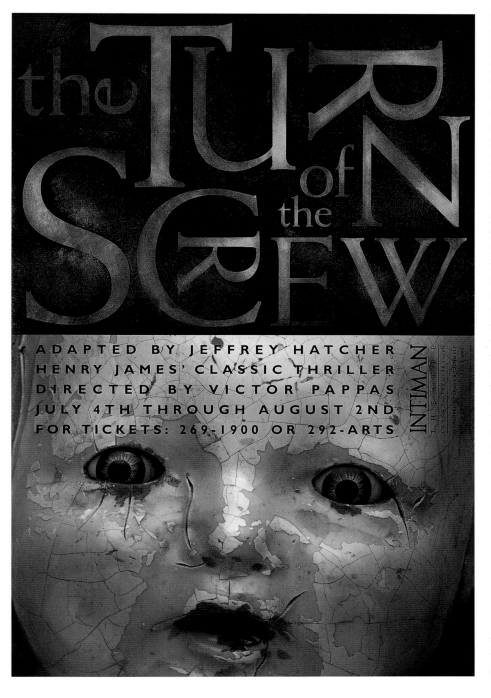

The basic design of this poster is worth noting. The type occupies the upper half of the poster while the photograph occupies the bottom half. While the design is simple, it is powerful—largely due to the exaggerated size, color and texture of the type in the upper half of the poster. Had the designer treated the type in a traditional fashion it would not have been nearly as successful. By pushing the type beyond the ordinary, the design becomes much more interesting. Rotating certain letters of the title reinforces the concept. By varying the size of different words and letters within words, the type is given vitality. By modeling the type with color, texture and different values, it becomes even more unusual. The most successful type design is often the result of refusing to be complacent. Try different effects and treatments until you've explored as many avenues as possible.

Turn of the Screw Poster
Traci Daberko, Dennis Clouse
Cyclone Design

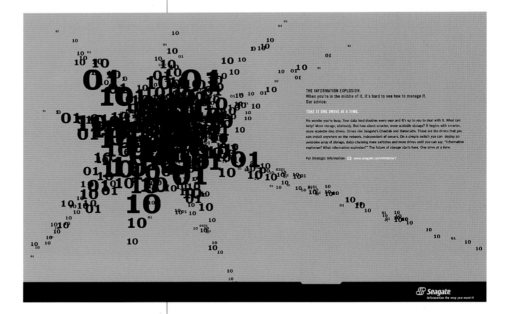

These two ads are ideal examples of type being used as an element to create an illustration. In each case, simple *1*s and *0*s are organized en masse to create recognizable shapes. These shapes correspond with the central concept and objective of the ads. In addition, the background color of the ads creates a cohesiveness that makes the ads work together as a campaign. The eye is initially drawn into the ads by the unusual illustration that poses questions that are answered in the text. Finally, a black bar at the bottom of the ads serves as the placeholder for the company logo. While these ads are simple in design, they have a certain power because of that simplicity. The body text for the ads need not be any more complex than it is since the type illustrations are very active. Reversing the product name and the web site allows these important pieces of information to have special emphasis.

Seagate Ads

Joel Templin

Templin Brink Design

Type

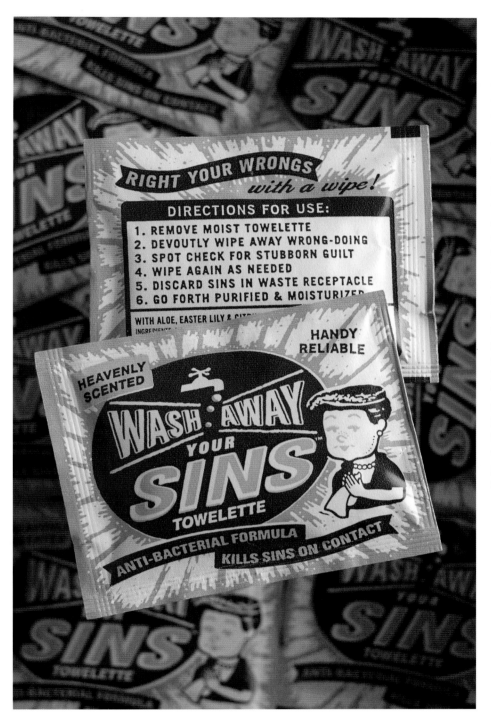

Among the most fun assignments a designer receives is the one to design something completely unessential but very entertaining. Such is the result of this tongue-in-cheek towelette design. While the product is silly, the type design is skillfully executed. When working with type, the perceptive designer looks for natural gifts in the configuration of words themselves that will make a design work, such as the fact that the words *wash* and *away* will both be virtually the same length when typeset. As a result, they will work to frame the word *your* which is the set up for the keyword *sins*. All of those words, along with the *towelette* identifier are centered inside the oval and become the focus of the design. The illustration of the woman and the texture around the oval both serve to draw the eye into the design. Notice that when you squint at the design, appropriately the word *sins* is the most prominent element.

Wash Away Sins Packet
Haley Johnson
Haley Johnson Design Co.

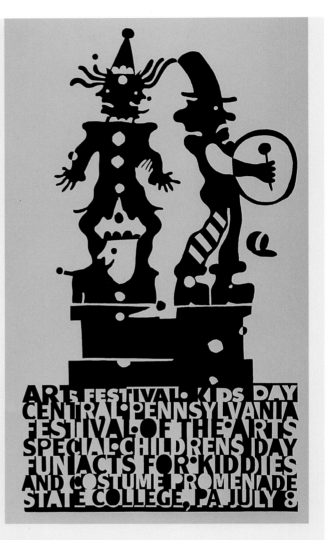

Not only does type provide all the information that's necessary to help these posters communicate; it is a beautiful addition to the design aesthetically. The illustrations literally sit atop these cushions of type. In addition, there is a very interesting interplay of positive and negative space within the type itself. There is no leading (space between the lines of type), and this gives the illustrations a solidity on which to rest. Notice the use of the circles within the type font. Not only is the idea innovative and interesting, it gives the type a unity that it wouldn't have otherwise. Once again, the design uses a sans serif font so that the type is simple enough to read when the lines are stacked one on top of the other. Nice touches like the absence of an inner circle in the *Os* lend an unexpected freedom to the design.

Arts Festival Posters

Lanny Sommese

Sommese Design

Shape

Shape is another element that can be used alone or in conjunction with line and type to help communicate the concept of a design. Shape can be defined as any element that's used to give or determine form. Shape can exist as a design element all by itself, without the aid of line or type. Most flags are designed with nothing but shapes. Even if you remove the color from the American flag, the design survives intact. Likewise, many fabric patterns are the result of designing with shapes; they effectively convey a style and mood, usually without the benefit of type. When shapes contain pictorial information in the form of decorative illustration, such as floral patterns or other subject matter, additional interest is added.

Shape Can Be Created in a Variety of Ways

A photograph, illustration or block of shading can provide shape. If you're designing a poster and have used line and type to communicate, but still feel the need to strengthen the idea through the use of art, any art you add will also add a shape. So photographs and other types of art will always impact your design in two ways simultaneously: first as shapes and second, through the content of the art.

When a single shape housing a photograph or illustration is added to a format—with or without type or line—the format instantly takes on a conceptual theme based on the content and shape of that piece of art. Therefore, it stands to reason that shape can be the strongest of elements, because beyond the impact of the shape employed, the subject matter of that shape will automatically either contribute to or distract from the intended idea. Consequently, it is critical that shape in the form of a photograph or illustration be used carefully.

Both line and type can also serve as shapes on a format. A single line can be prominent enough to create a shape, or a group of four lines can become a border that imposes a shape on the format. Type can be set into a block of text that also composes a shape. The illustrations on page 54 all use line or type to create shape.

Most flags are designed with nothing but shapes. If you remove the color from the American flag, for example, the design survives intact. When shapes contain illustrations, or any subject matter, additional interest is added.

Shape

Shape Can Sustain Interest

Shape is often used to hold the interest of the viewer. On a page that is heavy with type, shapes—in the form of photographs, illustrations or simply colored areas or textures—can serve as a relief to the reader. Shapes can serve to break up the copy into smaller segments, which psychologically allows the reader to read in smaller pieces.

Shape can also be used to separate and organize, and can hold the viewer's attention that way. For example, type can be put into a shape and placed within a larger block of text. This is often referred to as a sidebar. Sidebars typically deal with a subtheme of the main story, but are just as valuable visually because they add variety to the page.

When a format is highly structured or necessarily loaded with type, color shapes can be useful to give the page a freer form and add interest. In the example at right, the same page of type is shown with and without color boxes. Clearly, the added shapes draw the eye to the layout on the right. Be careful not to use shape indiscriminately. You will add strength to your design if you can give the page added meaning by the use of shape—instead of using shape simply to decorate.

Shape Organizes

Much of design is nothing more than the organization of elements to support a concept. But the way those ele-

ments are organized can make all the difference. For example, type and shapes placed randomly on a page can be confusing, but solid shapes behind type can serve to organize the body copy.

Text type itself will usually take on a shape when it is set in a column or box; it is not always necessary to place type within a shape that consists of a line or a shaded area. Sometimes the shape of the type itself is enough to break the page up and hold the interest of the reader. When designing a layout, ask yourself if the design is better without the addition of a box to hold the type. Remember our earlier lesson concerning the diamond concept, and eliminate any unnecessary elements in your design.

Shape can also be used to
separate and organize.

Shape can also be used to separate and organize, and can hold the viewer's attention that way. For example, type can be put into a shape and placed within a larger block of text. This is often referred to as a sidebar. Sidebars typically deal with a subtheme of the main story, but are just as valuable visually because they add variety to the page. When a format is highly structured or necessarily loaded with type, color shapes can be useful to give the page a freer form and add interest.

Shape can also be used to
separate and organize.

Shape can also be used to separate and organize, and can hold the viewer's attention that way. For example, type can be put into a shape and placed within a larger block of text. This is often referred to as a sidebar. Sidebars typically deal with a subtheme of the main story, but are just as valuable visually because they add variety to the page. When a format is highly structured or necessarily loaded with type, color shapes can be useful to give the page a freer form and add interest.

Type alone (left) seems less organized than type with solid shapes (right), which reinforce the type's organization.

Type can be set to create a shape
Type can be set to create a shape
Type can be set to create a shape
Type can be set to create a shape
Type can be set to create a shape
Type can be set to create a shape
Type can be set to create a shape
Type can be set to create a shape
Type can be set to create a shape
Type can be set to create a shape
Type can be set to create a shape
Type can be set to create a shape
Type can be set to create a shape
Type can be set to create a shape
Type can be set to create a shape
Type can be set to create a shape
Type can be set to create a shape

O

r a
character, when used by itself, can
provide a shape.

Both line and type can also serve as shapes on a format. Lines can be used by themselves to create a border or another shape, and even a single character of type can provide a shape.

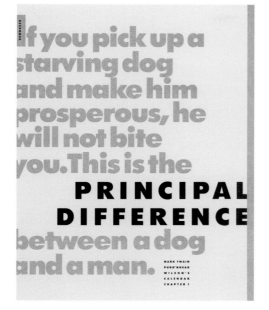

Depending on its configuration, sometimes the type itself is enough to create a shape that will hold the viewer's attention.

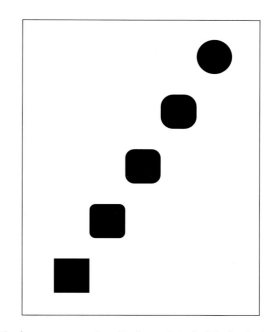

Notice how your eye automatically wants to find the beginning and the end of a design, and will follow, in order, the steps of a transformation. Because of this natural tendency, shape can be used to lead the viewer's eye.

Shape Can Be a Conceptual Tool

Through the use of shape you can lead the viewer's eye through the design to help that viewer understand the concept. The example above right shows the metamorphosis of a circle into a square. Notice how your eye automatically wants to find the beginning and the end of the design, following the steps of the transformation. Rarely will your eye first be drawn to the middle of such a design. Likewise, in a layout that consists of many elements, the eye will search for an object or shape that seems to give the design a place to begin and will follow the design to the end point in an effort to understand it. Sometimes the eye will be drawn by the largest element, sometimes by the most brightly colored or, in a layout with many squares but only one circle, by the shape that differs from all the others.

Have you ever considered that type is nothing more than shapes that have symbolically taken on special meaning when placed in a specific order? We learn to find the first letter of the word and read the symbolic shapes in proper order to make sense of the message.

As human beings, we are drawn to shapes that we identify with. A picture of another human being is usually the first element that the eye will go to when viewing a layout. A photograph or illustration of any subject matter will also effectively attract the eye. Large type is another element that attracts the eye, although it is not as alluring as a visual. The last thing to draw the eye is usually a shape consisting of small type. As an example, when you look at a menu in a restaurant, what attracts your eye first? Is it the small descriptions of each of the entrees or the photographs of the food itself? Is it the price of each item or the name of each dish? You will probably find that you zero in on the photographs of the food first, then on the name of each dish, then on the price of that item or the description of the entree depending on your end goal. If you are hoping to save money, the price may be a priority. But typically the small-type description will follow any shape or larger type that carries more important information.

What to Consider When Using Shape

1 *What kinds of shape will be most appropriate to your concept? Will you use photographs? Illustrations? Shaded areas?*

2 *How can the shapes you're using be made to sustain the viewer's interest? Will shapes be used to break up blocks of text or to unify other elements?*

3 *What shape is your text taking? Does it make sense to break your text up into different shapes in order to improve the communication of your message?*

4 *Can shapes help you lead the eye through your design? When you look at your design, where does your eye go first?*

5 *Have you successfully removed any shapes that distract from the idea of the design?*

Since we're so used to seeing shapes of all sorts and to interpreting their meaning in everyday life, it's easy to take the importance of shape for granted in our design work. But learning how to use shape to hold the attention of the viewer and to lead the viewer's eye through your design is important. Train yourself to initially ignore the content of the shapes you use and to look at your designs with an eye that is sensitive to seeing how the shapes you've chosen work in tandem with other design elements. Once the shapes are working in harmony with line and type, then the content of the shape becomes critical. Of course, often the content of the photo will determine the dimensions and even size of the shape you intend to use.

Ultimately, shape is the most powerful of the elements since it carries a double whammy—its natural size and dimension and the content or information it contains.

E X E R C I S E

EXPLORING SHAPE

Getting Into Shape

A designer must learn to look beyond the subject matter of the shapes used and to understand that the shapes themselves will either help communicate or distract from communication.

For this exercise you will need one or more magazines, several sheets of tissue paper and a thin black felt-tip marker such as a Sharpie.

Open the magazine (or magazines) and find four opening feature spreads or four advertisements. Place a sheet of tissue paper over a layout and tape it down at the corners. You might have to use several sheets of tissue paper, since the idea is to begin to see the shapes on the page without being distracted by their subject matter.

Now, as in the illustration at right, use the felt-tip marker to draw a line around the various shapes represented on the page. You may even elect to follow the contour of the headline as you bounce over upper- and lowercase letterforms.

What do you notice about the dominant shapes on the layout? Which ones jump off the page and which ones seem to play a minor role?

Do the same with each of the four layouts and then compare their strengths and weaknesses. Which one seems to be the most successful? Which one has shapes that hold your interest? Which layout uses the most varied shapes? Does it seem to be an asset to the layout?

SEED
LINGS of the DSVC

BY PHIL HOLLENBECK

Sometime in the summer of '94, I had another brainfart concerning ROUGH. I thought, "Man. People in this business are dropping babies faster than I'm losing my hair. This calls for a story."

The 25th issue of ROUGH (Sept.'94 Volume 4 #1, back issues available) had been assigned to Peterson and Company, so I gave Jan Wilson (no longer at Peterson) a call and said, "Hey Jan. Phil here. Listen, I want to do a feature on babes." She said emphatically, "No! No Phil! We're not going to do any chick spreads. Forget it."

"Jan. Jan. Oh ye of little faith. I'm talking babies here...get it? Newbies. Sucklings. New people on the planet. Human droplets from the parental units' love connection."

Well, needless to say she was surprised and thought it was a great idea. I called in photographer Holly Kuper to shoot the little rascals with the responsible parties, their parents. Peterson and Crew came through with great design (no surprise) and that ROUGH is still one of my all time favorites.

So we fast forward to the summer of 2001. And guess what? The DSVC members' hormones are raging again. Naturally, Peterson and Co. came to mind for the design. But I wanted a fresh photographer. Holly had her 15 minutes so I thought I would give Glenn Katz a shot. Besides, he deserved a fun shoot if for nothing else than all the sweat equity he has put into our art auctions. Now I've got the shooter and the shootees. A sequel to the original "Summer Babes" ROUGH. But aren't sequels notorious for being less than average compared to the original? Damn. A concept is needed. What to do? Oh, what to do? Something fun. Something to engage the ROUGH reader. Got It! A game. Everyone likes games, right? So how's this for a game? Try to match these sweet beanie babies on the opposite page with the ones who will be picking up the college tab in the year 2020, if the planet survives that long.

TURN THE PAGE ⟩ MATCH THEM UP

[8] [9]

This spread, from an issue of *Rough* magazine (the official newsletter of the Dallas Society of Visual Communications) is a good example of how individual shapes are used to create visual interest within a particular layout.

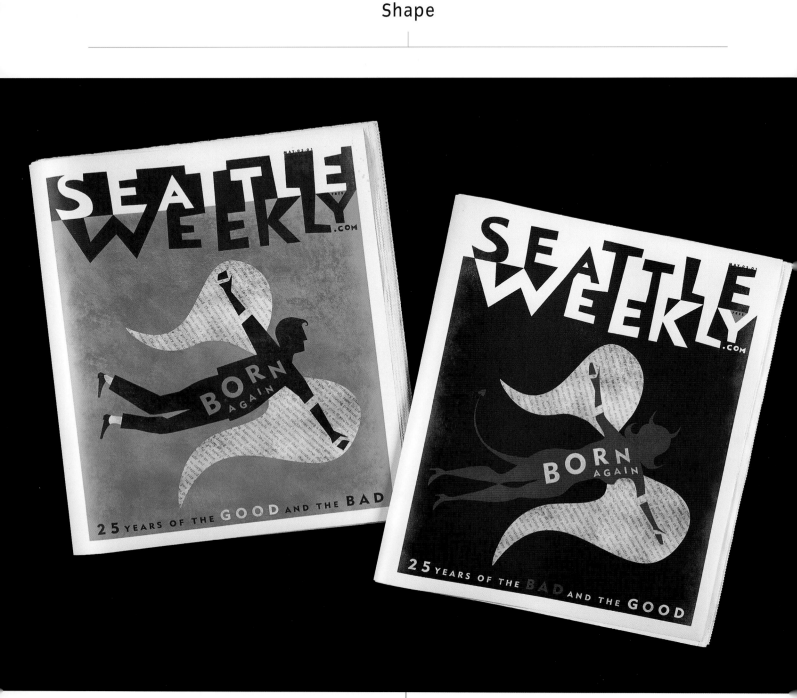

The beauty and success of these cover designs for *Seattle Weekly* lie in the effective use of shape—not only in the illustration, but also in the masthead type and even in the way the art sits in the format. The hand-drawn *Seattle* is knocked out of either a black bar or printed black in a white area at the top of the format. The space between the letters—or negative space—is as important as the letterforms themselves. Notice the interaction of the spaces and letters in the two words of the masthead. Obviously, this was not an accident but was carefully done to link the two words. Likewise, the illustration is made up of very simple shapes that work together to create a strong image. As important as

the shapes are, these covers are working on many levels. The blue background of the angel image and the black background of the devil image join to create a contrast that carries the idea of the covers. Notice also how the kicker type is working on each cover to strengthen the concept.

Seattle Weekly Covers
Dennis Clouse, Traci Daberko
Cyclone Design

Shape

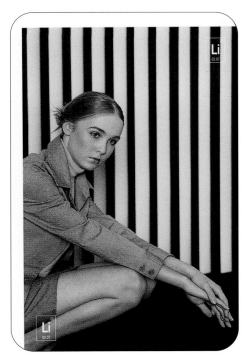

Sometimes the very shape of the format is key to enhancing a design. These cards promoting a line of paper are loosely imitating playing cards. Consequently, the shape of the card reinforces that idea and concept. A round corner goes a long way to make a design feel friendly and comfortable. We are so used to seeing design pieces trimmed into squared-off format that this simple refinement can be quite effective. With this promotion, the uncoated nature of the paper adds a softness to the cards. The paper also gives the printed photographs a soft feel which, in combination with the round corners and the paper itself, combine to create a favorable impression.

Elements of Style Promotion
Lana Rigsby
Rigsby Design

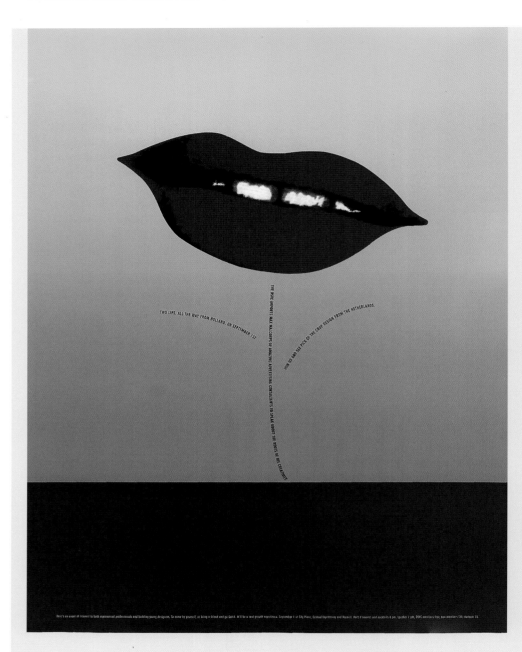

The concept of this poster is carried by virtue of the shapes involved. The lips create a simple tuliplike shape that reinforces the fact that this visiting design speaker is from Holland. Once again, the beauty of the concept lies in combining two elements that are not normally put together: a tulip and two lips. The creation of a powerful concept does not require an inordinate amount of genius—just an effort to see the most logical way of creating the unusual out of the usual. The challenge was to present this unique concept in a way that would not distract from the basic idea but, instead, realize its full potential. It seemed natural to set the type to simulate the stem of the flower. A horizontal division of the poster was created to provide a grounding place from which the stem could grow. The details of the event were placed along the bottom of the poster in small type.

Two Lips Poster

Scott Ray

Peterson & Company

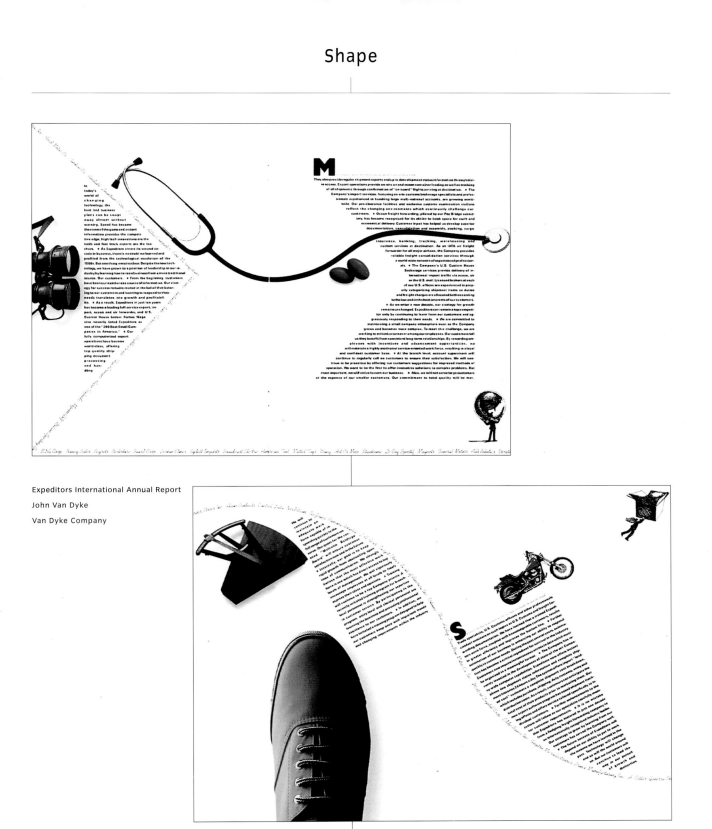

Expeditors International Annual Report
John Van Dyke
Van Dyke Company

Not only can shape be used effectively in photographs and with other art, but this annual report shows an outstanding use of shapes created with type. These typographic shapes are carefully combined with photographic shapes to create an intriguing layout. The designer let various photographic images create their own shapes and then complemented them with well-planned typographic shapes. Each spread is constructed with these basic shapes as the basis of the design. Notice in particular how the stethoscope, pills and binoculars are intertwined with the shapes of the type to activate the format. Also notice the amount of white space used on the spreads. This "luxury" of space is actually a necessity to make page layouts that are easy on the eye.

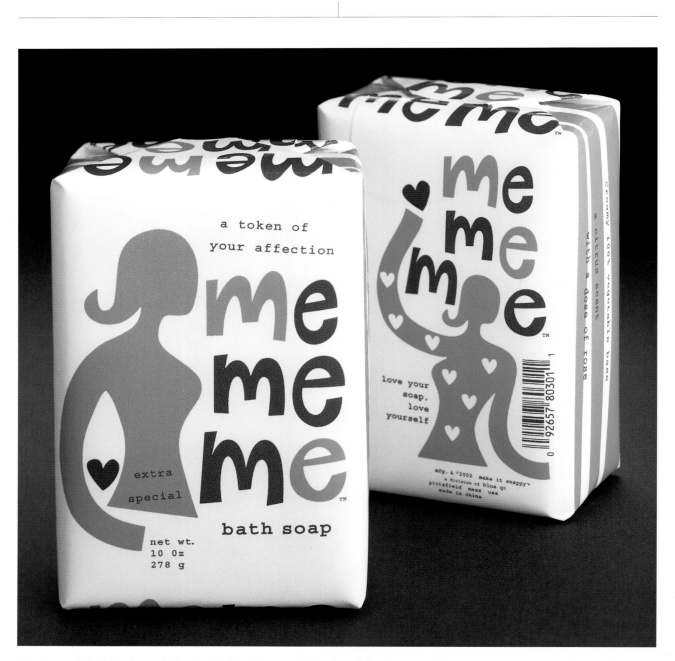

The shape of the letterforms in the Me Me Me title are an imitation of the drawing of the woman. A secret to successfully combining elements is to either make them very similar or very different. In this case, the problem is solved by making the art and type similar. No more detail is needed in the illustration than what is provided; the shape is obviously female and in sync with the nature of the product. Often, the simplest way to present an idea is the best. As in this example, start simple with basic shapes and add detail only when the design requires it for better communication or more style.

Me Me Me Bath Soap Package

Haley Johnson

Haley Johnson Design Co.

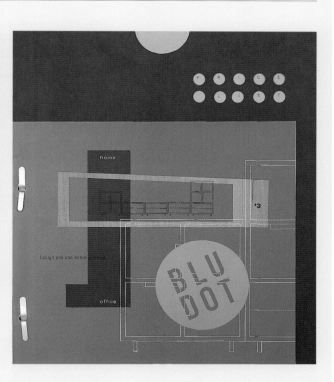

BluDot Furniture Catalog

Sharon Werner

Werner Design Werks, Inc.

You won't find a design piece in this book that better exemplifies the power of designing with shape than this one. From cover to cover, shapes define this furniture product promotion. Even the BluDot company logo is done in a circle shape. What a perfect way to illustrate furniture—a field of design that relies heavily on shapes. The squared-off cover attached to a folder containing inserts is an ingenious way to have the brochure function on different levels. This way, the sexy part of the promotion doesn't get mixed up with the more functional facts-and-figures part of the piece. The best part of this design is that it is completely in step with the look of the product. Notice how the design of the furniture is mirrored by the design. An additional detail in the design of this piece is the selection of the paper stock. Manila folder-like paper is used on different parts of the pieces to reinforce the utilitarian nature of the products being offered.

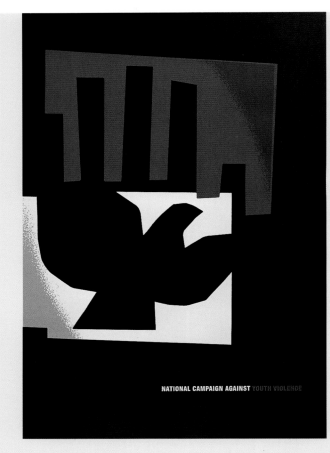

NATIONAL CAMPAIGN AGAINST YOUTH VIOLENCE

The union of unlikely combinations is probably the best way to create a concept. In this design, the hand combined with the dove creates an especially stark and powerful image. Had the images been more realistic, the poster would not have near the strength. What makes this poster great is the simplicity of the shapes. In addition, the color combination of black, white and red enhances an already strong visual and give added meaning. Imagine this poster printed on a white background. Or imagine the dove printed in white on a black background. The designer was smart to make the dove black on a white background since it still reads as a white dove only in silhouette. Because the illustration is as powerful as it is, the type by necessity is downplayed. However, the color palette is the same in the type, which ties it back to the illustration.

Youth Violence Poster
Joel Templin
Templin Brink Design

The designer of this poster used basic shapes and elements from the official 2002 Winter Olympics logo to create this image. The powerful aspect of this image is the fact that the snow-capped mountain image is embedded in the rest of the logo. Not much more is needed. Because the designer was not permitted to use the official Olympic logo (since this poster wasn't an official poster) he placed additional circle shapes above the year 2002 so that all the rings and zeros together simulate the official logo.

Snow-Capped Mountain Logo
McRay Magleby
Magleby and Company

Shape

This brochure again uses shape and texture to sell furniture. Photographs of the elegant furniture are surrounded by interesting shapes and textures that suggest fabric swatches appropriate to furniture. The effect? A brochure that draws the viewer's eye to inspect the products being sold.
The structure of each spread varies. Sometimes the designer uses a grid, at other times he uses a free-form shape (or shapes), and at still other times a single dominant image is surrounded by less important shapes. With this relatively complicated design, the grid is not immediately obvious, but it provides a subtle thread running through the design. In every case the layout avoids clutter, with all shapes and textures supporting photos of the product. The type is secondary (almost incidental) to the furniture and shapes surrounding it. The design is both entertaining and informative.

Metropolitan Promotion

Michael Cronan

Cronan Design

Every shape used in this poster is a derivative of basic circles, triangles or squares. By using basic geometric shapes, the poster automatically has a unified feel. While some designs seem to benefit by being less structured, this poster thrives on the structure. The impact of the poster comes from the starkness of the white background and simple colored shapes that come together to create a single image. Notice how the headline type of the poster is set along the same arc as the arm in the drawing. Rather than settle for the obvious solution, the designer elected to make the type a part of the design.

DSVC Crawfish Boil Poster
Scott Ray
Peterson & Company

Texture

t he fourth and final element of design that we'll discuss is texture. Texture can be defined as an object's visual or tactile surface characteristics and appearance, or as something composed of closely interwoven elements (such as a woven cloth). In graphic design, texture is most often used as a secondary element to reinforce an idea, rather than as the primary element to communicate a concept. However, it is a powerful addition to your design because it can add depth and interest to an ordinary flat design. Especially in the world of computer design where the effort to design a usable interface often leads to flat color or white backgrounds, the skillful use of texture can add a new dimension to your design.

The Many Uses of Texture

Texture can be used to fill a shape or as an overall background for type and line to create a particular mood for a design. Even when texture isn't added intentionally, the design will contain some form of texture, such as the texture of the paper or computer monitor or of other materials used.

Contrasting textures that are not normally seen together can create an interesting feeling. For example, a close-up photograph of newly tilled dirt placed against a photograph of chrome plating can create an odd but intriguing look.

The example of the Mothers Against Drunk Driving (MADD) annual report on page 77 shows how texture—in this case, metallic and canvas textures—can be used effectively to communicate an idea. The steel binding of a ledger was photographed and placed next to a scanned canvas texture to give the piece the feeling of a ledger.

With the current ease of importing art into computer layout programs, designers are finding an unlimited number of uses for texture in their designs. Virtually any texture can be scanned into a program like Adobe Photoshop and incorporated into a design. Sometimes, instead of printing on an uncoated paper stock, the texture of the uncoated stock is scanned, imported and printed on a coated paper stock. This way, the designer will have photographic reproductions that retain the density and detail of being printed on a coated paper, with the additional textured look of an uncoated paper used as a background.

Texture can be used to fill a shape or as an overall background for type and line to create a particular mood for a design.

Texture can be used to fill a shape or as an overall background for type and line to create a particular mood for a design.

Texture can be used as an overall background for type and line to create a particular mood for the whole design, or it can be used to fill individual shapes.

Texture in Everyday Life

To better understand the use of texture as a design element, think of some of the uses of texture in your everyday environment and how these textures can communicate a mood.

When an interior designer begins to design the look of a room, the texture of the walls is of primary importance. For example, if the room has a southwestern decor, the designer may specify a stucco finish for the walls. Something more contemporary might call for walls of exposed brick or cement. A nursery will often be done in pastel colors and soft fabrics, whereas a den might seem to call for warm-colored walls, bookshelves and hardwood floors.

Have you ever been intrigued by the textures—both natural and manmade—that can be seen from an airplane? Flying over fields of wheat that are ready for harvest, you not only see the texture of the plants as a whole, but also the individual rows that create rhythmic patterns. Even houses and roads create interesting geometric patterns. As soon as you notice the textures that exist on nearly every surface, you'll begin to develop an awareness of the textural possibilities that can powerfully reinforce the concept of your design.

Finding Appropriate Textures

Where do textures come from and what varieties are available? As mentioned previously, the first texture a design has is often the paper you use. Recycled and handmade papers, in particular, may have a noticeable texture or may contain flecks (another layer of texture); coated papers are manufactured by "calendaring" the surface to impart a smoother feel to a printed piece than uncoated papers do.

The background of a piece of art, such as a photograph or illustration, may contain a texture. And with the use of a photocopier or a scanner, you can easily manipulate photographs or artwork to create an infinite variety of textures to enhance your design. If you have access to a photocopier or scanner that permits you to enlarge your original, experiment with enlarging different common textures, such as a crumpled paper bag or an old pair of blue jeans. After it has been copied many times, the copier will remove the midtones and convert all tones to either white or black. Notice how interesting these everyday textures can be, and make a mental note of which ones might work in a future design. A scanner will capture the texture and allow you to manipulate it in Photoshop. By adjusting the contrast, hue, saturation, etc. the possibilities are endless.

Textures Available Through the Printing Process

Along with standard offset lithography, other textures available through printing processes include silkscreen, embossing, debossing and foil stamps, as well as engraving and its less expensive cousin, thermography. There are also the printing methods of the past, such as letterpress.

Silkscreen involves creating a negative mask for your art and pushing ink through a mesh screen to create vivid color and an opaque quality not easily available with offset lithography. When silkscreened, solid areas of color have a velvety texture that can enhance a design.

Embossing and debossing involve creating a die that has actual dimension and then, through carefully applied pressure, forcing paper to assume the dimension of the die. Since there is no ink on the image, the result is purely textural. Foil stamping also uses a die, but instead of raising or indenting the surface of the paper, a foil is heatset into the paper. This foil can be a metallic, such as silver or gold, or it can be a flat pastel or other color.

Engraving and thermography will leave your image with a raised surface on the paper. This process is attractive because even type can possess a feeling of dimension—albeit slight.

Letterpress uses hot-metal die casts to transfer ink to the sheet. The result is very tactile because the casts leave an impression in the paper; letterpress is often used as a less-expensive alternative to embossing.

Texture Must Support the Concept

We have discussed the central role that concept plays in design; that is, the idea is of primary concern, and anything that distracts from the idea is to be discouraged.

Since texture can be such a fun element to use, it might on occasion be tempting to use a texture that is not sufficiently related to the concept of your design, or to use texture that is appropriate but that overwhelms the rest of the design. To avoid this scenario, keep in mind that texture should be used in a design to strengthen the idea—never simply to decorate.

The annual report design by Steve Pattee and Kelly Stiles on page 79 is, I believe, a prime example of the appropriate use of texture. The booklet is for the Des Moines Metropolitan Area Solid Waste Agency: the cover is printed on crudely recycled paper and creates a feeling that is very appropriate for the company.

On the other hand, some designs use such a heavy texture that the type that is printed over it is virtually unreadable; even if the texture was appropriate to the concept (and it's often not), by obscuring the type it still impedes communication of the piece's message.

If your idea doesn't immediately call for the use of a texture to reinforce your concept, it may be better to wait until other elements are in place and then see if the addition of a texture will enhance your design. Make it an afterthought rather than forcing it into a design where it really isn't needed.

If texture still seems appropriate, consider the many textures that are at your fingertips and choose one that won't overwhelm your design. If you do choose to use a less subtle texture, design other elements accordingly—for instance, pick a bolder typeface that will be able to stand up to the texture you've picked. In general, however, textures that are playing a supporting role in designs will need to be subtle so they don't get in the way of other, more important, elements.

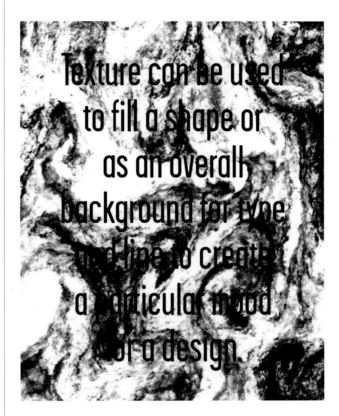

Some designs use such a heavy texture that the type printed over it is virtually unreadable; even if this texture is appropriate to the concept, obscuring the type will still impede communication of the message.

What to Consider When Using Texture

1 *Will an overall texture help to convey the idea of your design? Will texture be used to fill individual shapes or other portions of the design?*

2 *Have you considered the textures that surround you in everyday life? Will any of these textures strengthen your design?*

3 *Even if texture is not to be added graphically to your design, what role will be played by the texture of the paper you use?*

4 *Will you use artwork, in the form of a photograph or an illustration, that conveys a feeling of texture?*

5 *Is silkscreen an option? Have you considered using an embossing or debossing die? Will a foil stamp be appropriate to your idea? (Don't forget alternative printing methods.)*

6 *Do the textures you've chosen to use support or overwhelm the concept of your piece? Is the texture in your piece an integrated part of the concept or does it feel like it was added on at the last minute?*

The contrasting textures of the thin, crisp line next to the fuzzy, more loosely defined stroke of a paintbrush give this logo, by Nhan T. Pham of Peterson & Company, much of its effectiveness.

EXERCISE

EXPLORING TEXTURE

Using Texture as a Background

Choose three household items that can be used as background materials. Each of the items you choose should have a texture that distinctly contrasts with the other two. For example, you might choose a paper bag, a piece of burlap, a patterned piece of cloth, a panel of wood, a chunk of cement and a piece of tile.

Now find another familiar object, such as a spoon, a piece of jewelry, or some other fairly small item. Place this item on each of the three background textures and notice how the backgrounds change the effect of the chosen object. You can see how compatible, for example, a piece of jewelry might be with a shiny black ceramic tile. But, interestingly, the same piece of jewelry has a completely different look when placed on a piece of cement—even though the object itself has not changed.

A common trend in photography is to purposely combine objects that are in vast contrast to each other. This contrast catches the eye of the viewer because the items displayed are so different. This concept also works for design when, as in the example at left, a very crisp line is used in combination with the brushstroke of a paintbrush in a logo or other design.

Experiment with different combinations of materials and textures to see which best support your concept.

While the most obvious way to use texture in design is through choice of paper stock, every now and again the designer desiring to break out of the mold will use a completely unexpected material. Such is the case in this example of a business card designed for KEA Inc. This especially effective card is composed of paper tipped onto the surface of the metal to add a new dimension to the design. The impact of receiving this business card is undeniable. The texture used in this card works perfectly with the fact that this client is a print broker who specializes in specialty production techniques such as embossing on metals.

KEA Identity

Joel Templin

Templin Brink Design

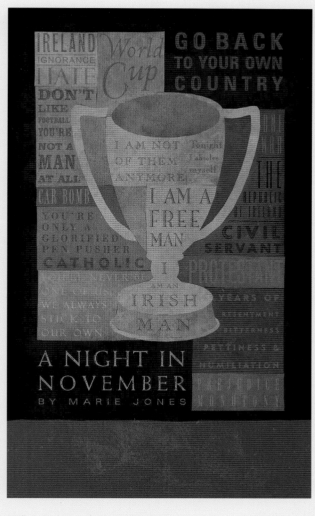

This beautiful poster series is a good example of using type to create texture. At a distance, the type is reduced to being just texture. Upon closer inspection it gives you clues as to the nature of the productions. The choices of fonts, which are primarily classic, also add sophistication to the design. Combined with the rich color palette and wide border, the design is classic yet contemporary. The illustrations keep the design from being stuffy and portray the different productions in a playful way. Not only does the type create texture but it also creates an underlying roughness to the entire design. This same design done with crisp type in hard-edged color would not be nearly as effective. The designers elected to use a color palette that is complementary from one poster to the next.

Madison Repertory Theatre Poster Series
Traci Daberko, Dennis Clouse
Cyclone Design

Texture

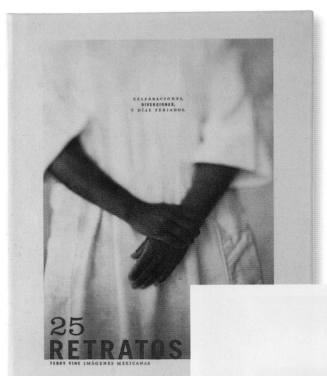

Unfortunately, this design book does not allow you, the reader, to pick up and handle this piece promoting Terry Vine, a Houston photographer. Were you to have this opportunity, you would be pleasantly surprised by how good this piece feels to the touch. Made to simulate a book, the piece is actually a box that houses a smaller portfolio of the photographer's work inside. The cloth cover is pleasing to the touch and brings to the viewer, along with the beautiful photography, a fine sense of sophistication. The designer exhibited restraint and relied primarily on the use of classic type and unusual materials to showcase this photographer's images of the people of San Miguel, Mexico.

25 Retratos

Lana Rigsby

Rigsby Design

While much of the design we have shown in the book so far is very simple in nature, here is a design that succeeds in spite of being fairly complex. In fact, the entire design takes on a textured look by virtue of its complexity. This unusual approach to hand soap goes contrary to the expected solution and uses humor to attract the eye. It is hard to resist the look of this bottle on merits of the name alone. But the addition of a rose, diamonds, belts and other visual jewels makes the design quite attractive. To top it off the label is placed on a black bottle, which adds to the unexpected nature of the design. A complex design like this can be a design challenge. But underlying this design is a fairly simple template, which gives the design a skeletal structure upon which to build.

Queen Hand Soap Bottle
Haley Johnson
Haley Johnson Design Co.

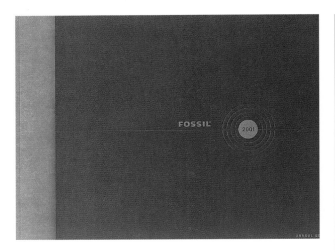

From the cover and throughout, this annual report for Fossil uses texture to carry the design. Fossil, by nature, effectively relies on nostalgia to position their products. Thus the notion of old ledger paper and classic catalog art are entirely appropriate. This book required a high level of design skill and sophistication to move the reader through the annual report, treating the eye to nostalgic images while, at the same time, educating and vouching for the financial stability of the company. I counted at least a half dozen different printed paper textures in this annual report. Upon each texture sits a wonderful collection of old toys, posters, and memorabilia—each one enhanced by the texture behind it. The designer who learns how to use texture to influence the mood of the design and consequently that of the reader, will have learned one reason that Fossil's design has been so successful for so many years.

Fossil Annual Report

David Eden

Fossil

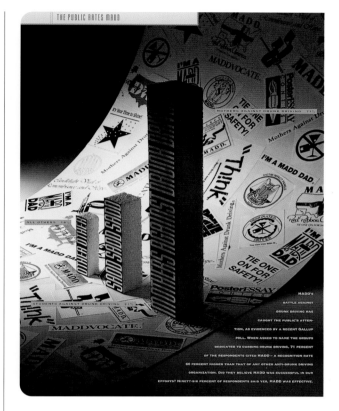

This annual report was designed to communicate the financial status of Mothers Against Drunk Driving (MADD) and satisfy donors that donations are used wisely within the organization. To help convey this concept, the entire report is designed to look like a ledger. The cover consists of a composite of two shots: a metal ledger binding and a canvas texture. Inside the report, the "Message from the President" is printed on a simulated ledger balance sheet to further carry the theme of responsible financial stewardship.

The textures in this piece are critical to communicating the serious concept. Also notice how sparingly color is used. Besides the full-color shot of the metal binding on the cover, all other photography is black and white. Use of color in the graphics is also limited.

MADD Annual Report

Bryan Peterson

Peterson & Company

Texture

One of the most beautiful parts of this identity is built into the apparently solid colors displayed on each of the stationery pieces. Upon close inspection the viewer discovers that the solids contain a subtle texture. This seemingly small refinement to the design, along with the use of engraved type, give this identity a wonderful feel that seems so appropriate to the name of the company. Even though this company falls within the common notions of a "high-tech" firm, the identity is refreshingly low-tech. The rounded corners on the card design are yet another nice touch. The final good decision was in the selection of the paper stock for the business card design. It is an uncoated toothy paper that enhances all that is going on within the design. The choice of a sans serif font is the finishing tweak to the design.

Farmhouse Identity
Brian Gunderson
Templin Brink Design

Texture

You've got to admire the tenacity of this designer for having the courage to use corrugated cardboard as the cover of this brochure: the distressed, pre-recycled cardboard gives each brochure a kind of individuality. Considering that the piece addresses topics such as recycling and the environment, what better way to communicate this message to the reader? It's likely that practicality became a concern in the production of the piece, but once that issue was solved, the impact this piece makes on the reader is significant because the visual execution reinforces the concept. This brochure teaches us an important lesson: Rule nothing out. Sometimes your tendency might be to instantly nix an idea because it is so far-fetched. When a great idea hits, don't dismiss it until you are sure there is no practical way to execute it. This piece proves there is usually a way to accomplish the seemingly impossible to great creative effect.

Des Moines Metropolitan Area Solid
Waste Agency Annual Report
Steve Pattee and Kelly Stiles
Pattee Design

Chapter Three

Structure

now the fun begins. Once you understand the elements of design—line, type, shape and texture—you're prepared to use these raw materials within a structure. Remember: good design structure is the result of a skillful combination of elements.

In building construction, the builder must understand when to use brick, and when lumber, steel or concrete would better suit his purposes. Using building materials as if they were interchangeable would result in disaster. A house may employ all four of these materials, but each for different intents—lumber for the frame of the house, brick for the exterior, concrete for the foundation, and steel rebar to reinforce the concrete.

In design, you'll have the building elements of line, type, shape and texture at your disposal; like the builder, with the various materials at his disposal, you'll discover that each element has different purposes, and that you can't always use these elements interchangeably. Not every design should necessarily use all four of these elements. The careful building of your design will result in the most powerful communication to your audience.

Finding the appropriate use of line, type, shape and texture is the secret to creating an effective design, and the bylaws that govern good combinations of these elements are principles of structure. In this chapter we explore the four primary principles of structure—balance, contrast, unity, and value and color—to gain an understanding of each as it applies to building strong design.

In the end, the best results will be achieved through the use of these principles combined with your creativity.

Balance

imagine yourself sitting at one end of a teeter-totter at your local park: you with the seat you occupy on the ground and the seat across from you empty and lifted off the ground. What kind of weight is required in the opposite seat to balance your weight evenly across the beam? The logical answer—and probably the first one that springs to mind—is that a person of equal size to you would properly balance your weight. However, that's not your only possibility; for instance, couldn't two persons, if each weighed half your weight, likewise balance you if they both were to sit at the other end of the teeter-totter? Of course.

There's Always More Than One Way to Achieve Balance

Another possibility is that a smaller person could balance your weight if you were to slide toward the center of the beam until balance was achieved. In fact, if you center yourself between the two seats directly over the center beam, you can achieve balance without the help of another person. From there, let your imagination take over and you'll find any number of solutions, including removing the bar that carries the seats from the beam and relocating it to an off-center position, thereby creating a new center of balance.

A teeter-totter functions as intended when there are weights of relatively equal size balanced on each side of the beam. In design, visual balance appeals to us because we rely on balance in nearly everything we do. The human body is balanced, enabling us to stand and move; so are the tires of a car. But balancing the elements of your design does not necessarily mean using symmetrical balance with an even number of elements that mirror each other—think of a tripod, for example, which achieves balance with an odd number of legs. In fact, while symmetry is useful for certain solutions, it would become tiresome if every design required symmetrical balance to succeed.

Balance Can Create a Mood

In art, balance can create a powerful mood. Can you think of a classical painting that relies on symmetry to achieve a feeling? For instance, how about *American Gothic* by Grant Wood? This famous image of a farmer holding a pitchfork, standing with his wife by his side, communicates a calm—some would even say stagnant—feeling that is reinforced by the equal balance of the two figures centered in the format.

By contrast, *Starry Night* by Vincent Van Gogh has a very unstructured, freeform feel that's in part the result of the lack of strict balance. Balance or lack of balance can likewise affect your design, depending on the mood you want to create.

Symmetry

In the format at the top of the next page, we'll place a single horizontal line. If our goal is to achieve pure symmetry—that is, a design that's centered on all sides—we're somewhat limited in where we can place the line. True symmetry requires us to place the line centered left to right and top to bottom; with a vertical line, we would still center it left to right and top to bottom to achieve absolute symmetry.

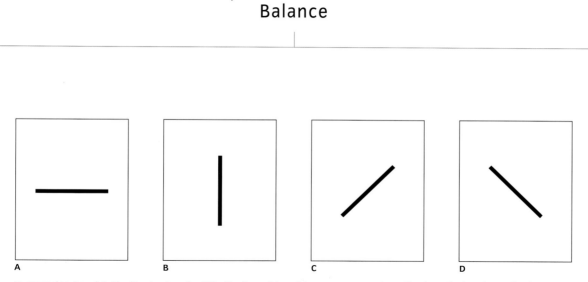

In examples A and B, the line is placed within the format to achieve pure symmetry—that is, a design that's absolutely centered on all sides. In examples C and D, the line is placed on a 45-degree angle, so it is not absolutely symmetrical in placement but achieves a somewhat different feeling of balance.

Now let's put the same line on a 45-degree angle. When it's placed in the format centered left to right and top to bottom, it doesn't have the same feeling of complete symmetry, but the design is still balanced. Looking at the same angled line reversed, we achieve a slightly different feel, but maintain the same degree of symmetry and balance.

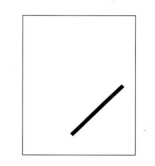

A line placed randomly within a format will create an asymmetrical design, but will achieve a feeling that a symmetrical design can't.

Asymmetry

Now, using the same line, place it in the format at any random position. Unless the line is placed perfectly horizontally or vertically, you'll automatically create an asymmetrical design—no matter where you place it. Is the design balanced?

Strictly speaking, the fact that the line is not centered pulls the design out of balance; at the same time, it creates a feel that the balanced design doesn't achieve. As mentioned earlier, the goal is not always to achieve an absolute balance. Sometimes the interest achieved by a lack of balance strengthens the impact of your design.

Let's do another visual exercise. Suppose you create a format and introduce a shape into it. In my case, I've chosen to use a dot of roughly the same mass as the line in

the illustrations above. Now try to place both the shape and the line in the format to create a perfectly symmetrical design (see next page).

If you place the dot above the line, is the design perfectly symmetrical? How about to either side of the line? You cannot create a perfectly symmetrical design with these two shapes; even if you balance the design side to side, you won't be able to center it from top to bottom. The only way to create a design that's perfectly symmetrical is to introduce another line or dot, which will allow you to center the design completely. When you introduce a second dot into the format, you can achieve perfect symmetry.

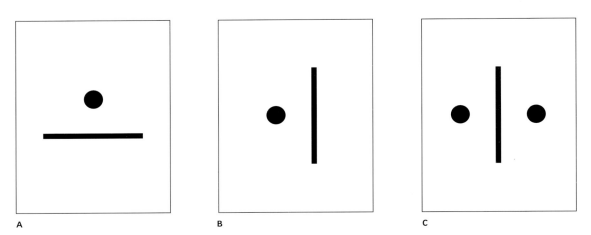

A B C

Perfect symmetry can't be achieved with just a single dot and a single line (examples A and B). You may need to add (or remove) elements to your design if you want to achieve perfect symmetry (example C).

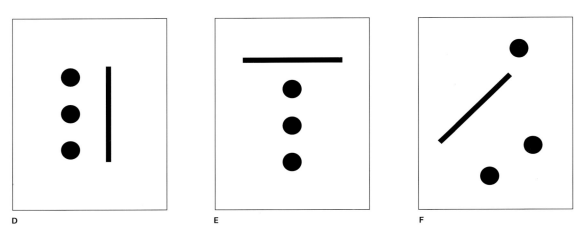

D E F

These illustrations show examples of asymmetrical balance. With three dots and a line you cannot achieve perfect symmetry, but you can achieve asymmetrical balance by evenly distributing the total mass within the format.

Asymmetrical Balance

Now place a third dot into the format. Once again, it's impossible to have complete symmetry, because the third dot will not allow you to center the design both vertically and horizontally. It does, however, allow me to demonstrate the next level of balance.

Going back to our teeter-totter example, I mentioned the possibility of balancing your weight with two persons of exactly half your weight. While this arrangement would not be symmetrical, it would nevertheless be balanced.

The illustrations above show that it's possible to place the three dots and the line in the format in a number of configurations and still distribute the mass in the format equally. Balance does not necessarily require perfect symmetry. In fact, while designs that use absolute symmetry can be very appealing when used for the right purpose, your possibilities are widened when you use balance to create interest without regard to perfect symmetry. This is called asymmetrical balance.

Balance

Tension

To create an entirely different feeling, let's try using the same elements while intentionally ignoring balance. What moods are created in the extreme examples below? All of these designs tend to activate the format space in a different way. Some of the designs create what might be termed tension.

At certain times, tension is useful to communicate the feeling of the design; sometimes tension is added to create interest by throwing a design out of balance. There are no rules to follow except the visual needs of your concept.

For example, if you are designing an editorial spread for a magazine with a war-torn region as subject matter, tension might be entirely appropriate. The concept of the design, or the text used in it, will give you an idea if an unbalanced feeling is appropriate for your piece.

Balance Using "Real" Design Elements

In the previous exercises I used lines and dots—elements in greatly simplified form—to get my basic ideas across. The possibilities for communication expand greatly as you use photographs, illustrations, blocks of actual text and other substantial elements in your design.

But don't rely on the content of a photograph or the words in the text alone to communicate your message. Instead, focus on the basic design of the format and how the position of each piece of art, each block of text and every bit of texture can enhance the concept. Always keep in mind that you can create feelings and moods with even the simplest of elements. As the elements you use become more substantial, your possibilities will become infinite.

As you learn to use balance to create mood, you enhance your design skills and enable more effective communication of your concept.

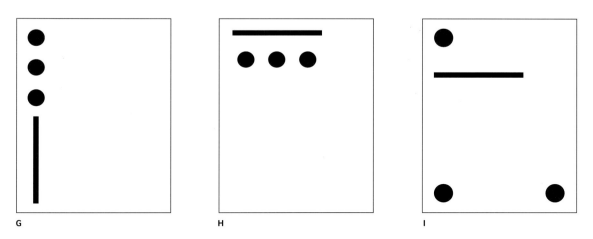

G H I

Sometimes effective design will be purposely unbalanced. These three examples show designs that activate the format in ways that a balanced design never could. You might say that some unbalanced designs create a feeling of tension.

What to Consider When Striving for Balance

1 *Which type of balance will be more appropriate for your concept? Does the idea call for symmetrical balance or asymmetrical balance?*

2 *Does your design need a purposely unbalanced look? If so, have you pushed your design to feel obviously unbalanced?*

3 *What elements will you use to achieve balance? Will you balance elements that are similar to one another or elements that are different?*

4 *What are the different moods you can create with the balance of your design? Have you used balance to its potential in your design? Is it contributing to your concept?*

5 *Have you let your concept dictate the needs of your design in terms of balance? (Be careful not to let your desire to achieve a certain look override the design.)*

EXERCISE

EXPLORING BALANCE

Symmetry & Asymmetry

The experienced designer can use both symmetry and asymmetry to create exciting effects. To explore the possibilities of combining symmetry and asymmetry, try dividing your format in half vertically, making the left half white and the right half black. At this point the format is symmetrically divided.

Introduce a number of black elements into the white half—in this case, I've chosen three lines and three dots. Likewise, place three white lines and dots in the black half of the design.

By placing the lines and dots in the same position on both sides of the format, you create an orderly feel. Next, try placing the dots and lines in random positions on both sides of the format. Then try placing the dots and lines in an orderly fashion on one side of the format and in a random arrangement on the other side. As you see, each configuration creates a different feeling.

Using simplified elements in this exercise helps you ignore the content that these dots would contain if they were full-size illustrations or photos in an actual design. Notice how the position of these simple elements helps to communicate the concept.

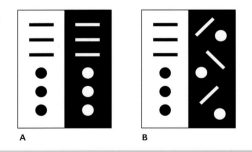

A B C

The experienced designer can use symmetry, asymmetry or a combination of the two. In example A, elements are placed in an orderly way on both sides of the design; in example B, elements are orderly on one side of the format and randomly placed on the other side; and in example C, elements are placed at random on both sides. Notice how each configuration creates a different feeling.

How To Be A Wicked Witch Book Cover
Dennis Clouse
Cyclone Design and Illustration

At first glance, an observer may wonder how this cover could possibly represent a good example of balance. Think of this design not in terms of balancing two mirrored sides, but of two different elements—type and shape—offsetting each other. The illustration on the left side is basically built of shapes, while the right side of the design is primarily type. The two are placed in the format in such a way as to create a sense of near-perfect balance. The dark vignetted border and the tail of the cat coming up the right edge of the cover do wonders to stabilize the design.

Balance

Art of Facts Brochure
Lana Rigsby
Rigsby Design

Visual elegance and sophistication can be achieved most easily by balancing the elements in a design. Visual tension is not always desirable depending on the subject matter of the design. Considering that this brochure is promoting the services of a law firm, elegance and sophistication are essential. From cover to cover, this brochure exemplifies great awareness of balance. An opposing page of solid color balances the intro page of type. A page of diagrams balances a page of body text. White space in this brochure is abundant, which also adds to the sophistication of the brochure. The predominant typestyle is a classic serif font that is easy to read. The color palette is soft and the paper uncoated, which makes the piece easy on the eyes. Everything in this brochure is working to relay the message that this law firm is appropriately innovative in its approach to client needs.

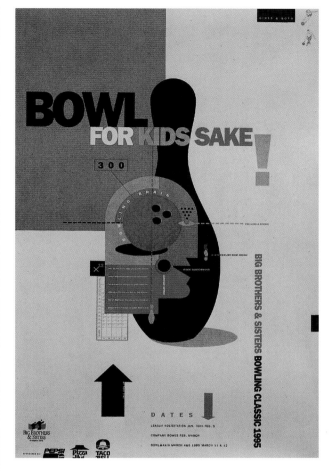

The structure behind the illustration on this Olympic poster is centered. The globe at the feet of the figure, the basic form of the figure itself and the wings are symmetrical. That said, everything that surrounds that structure is asymmetrical but designed to be in balance. Notice the position of the three birds around the figure. Even though one is on the left and there are two on the right, the left side is balanced by banners that flow from the torso of the figure. The harp is positioned to fall within the weight of the wings to keep the illustration in balance; any weight that is carried there is counterbalanced by the black portion of the moon over the figure's head. Balance is all about feel. There is no way to quantify the balance of a design; you must use your eye to determine the visual weight of each element and decide what needs to be done to balance it with other elements in the design.

Olympic Commemorative Poster

McRay Magleby

Magleby and Company

This poster is a good example of a balanced design that is almost completely asymmetrical. The only element in the design that is symmetrical is the bowling pin at the center of the image. (The right and left sides of the object are symmetrical, plus the object is centrally placed.) This pin acts as an anchor to allow the other shapes, typography and textures to float in the format. While the placement of these other objects isn't symmetrical, balance is achieved through careful selection and placement of each object. Also notice how the black shapes on the borders of the poster line up with other elements within the design. Another unifying aspect of the design is the limited color palette. Repeating neutral colors, such as red, helps tie the different sections of the design together. The paper color and texture are somewhat visible underneath the translucent ink colors, which also gives the poster a unified appearance.

Bowl For Kids' Sake Poster

Sonia Greteman and James Strange

Greteman Group

The right and left sides of this poster are perfectly symmetrical except for the subtle color change in each letter of the type. The design is very simple—and powerful—because the concept of the poster is instantly apparent. Any other embellishment of the art would have distracted the viewer from the simplicity of the concept. The fact that each small letter of type is a different color is a subtle touch that adds dimension and interest. The principle of contrast is also at work in this poster. The pure white of the cross stands out perfectly against the black of the body shape.

AIDS Poster
McRay Magleby
Magleby and Company

There is nothing that will force more balance in a brochure than having a hole drilled directly through the center. Every page, both front and back, must automatically deal with this given element. Consequently, it becomes the center of the pupil of an eye in one photograph and an element in a centered chart on another page. In many instances it is the center axis, vertically and horizontally, of the typography of the page. On a couple of pages it sits in the middle of a totally white page—with the exception of one typeset word that appears in the corner of the page. The result is that the book has a natural symmetry. The hole becomes the element that unifies every page and carries the concept through the design.

Global Design Alliance Brochure

Lana Rigsby

Rigsby Design

Balance

This CD design features a picture frame that is divided into two equal compartments. The natural solution is to place the picture frame into the visual center of the format. What becomes a little more critical is balancing the art that will occupy the picture space in each of the two photo compartments. In this case, the mass created by reversing the word fragment *Tex* out of a dark design motif such as the one pictured needs to be counterbalanced by the size of the fragment *oma* on the other half of the frame. Since the *oma* was to be placed on the photograph and not reversed out of a design motif—which would give it more weight—it was necessary to enlarge it to feel visually equal to the *Tex* on the other side. The roadside-park picnic tables also had to be sized to make them appear fairly equal or the designer risked throwing the composition out of balance. While all this concern over balance may seem frivolous, people will often unconsciously decide that they like a design based on this principle, which they recognize instinctively.

Texoma CD Design

Bryan Peterson

Peterson & Company

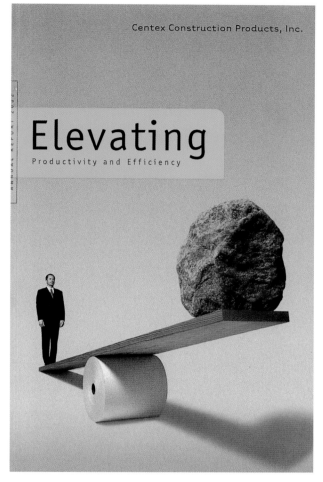

These two ads are great examples of the principle of balance in action. The top ad shows a wall of arrows and type coming from the right, while the left side is fairly calm and contains the headline and body copy for the ad. So how does this represent any kind of balance? This ad proves that a large expanse of nothing can balance what is, in essence, a large expanse of black on the right side of the ad. This contrast of value is what makes the ad work, along with the fact that the momentum of the arrows is all headed toward the empty side of the ad. Had the arrows been directed the opposite way, there might be a case for claiming that the ad is not visually balanced. The bottom ad works in a similar fashion except that the balance occurs horizontally. To place the headline and body copy exactly in the vertical center of the ad would have been a mistake. What makes the design intriguing is that the text is placed to the left of center. Remember that the goal is not always to achieve perfect balance in your design. Often a little visual tension only adds interest.

Seagate Ads

Joel Templin

Templin Brink Design

The very subject matter of this annual report is balance. The photograph illustrates the conceptual irony of two elements on a board defying what would be an expected weight advantage. But speaking strictly in a graphic dimension, the objects in the photo are very well balanced. All the elements on the cover design are, in fact, in balance. The type configuration is attached to the left margin, which adds weight to the left side of the brochure and counterbalances the mass of the rock, which sits at the right side of the cover. The company identifier at the top of the brochure is placed at the right to balance the weight of the title block. When designing a cover like this, trial and error is ultimately the way to go. Once you place the elements on the format and decide what size each should be, it is a matter of experimentation until you find the placement of each element that allows the design to be balanced.

CXP Annual Report Cover

Scott Ray

Peterson & Company

Contrast

think of a world where e-mail exists as the only form of communication. Imagine how often messages would be distorted and misinterpreted by the lack of emotion that comes with the dynamics of the written word. And how boring speech would be and how difficult it would be to communicate emotions verbally without the use of inflection—the contrasts of pitch and noise levels.

Imagine how dry music would be without the unexpected element of one instrument being played in contrast to the others. The crash of a cymbal in orchestral music that's otherwise subtle and quiet adds excitement and increases our listening enjoyment.

Or consider the sky. Without the benefit of a dark sky, it would be difficult, if not impossible, to see the moon. The darkness of night increases our visual enjoyment of the moon and sets the stage for such things as fireworks. In each of these cases, contrast is at work to enhance the experience.

Contrast is an especially important principle in graphic design, and a crucial tool to communicate an idea. It is also one of the most effortless principles to put into action. Many years ago, I knew a designer who would use black as his primary background and place upon it large sans serif fonts in white. While the formula was predictable, the positive effect was, too. This simple tactic, though somewhat unimaginative, was always effective in giving his designs power.

Contrast is Automatic

As soon as you add any element to a blank page, no matter how subtle, you've used contrast. Consequently, it may be one of the most undervalued principles of design, because its use is to some extent automatic.

Let's begin by using the example that we started with in the previous exercise on balance on page 86. Contrast was used to divide the format into two parts, one white and the other black. Even before you placed the lines and dots into each of the divided sections, you had the benefit of contrast at work for you—black against white. We then placed lines and dots on each half of the format to demonstrate balance.

What would happen if the size of these objects contrasted sharply—if, for instance, one of the dots was twice as big as the others? By contrasting the size of the elements, the design moves into another dimension and the designer has another tool at his disposal. If you were trying to achieve balance, it would be necessary to adjust the design to accommodate this larger object. Now let's make that same dot even larger. Because of the principle of contrast, further adjustment is necessary to maintain visual balance.

In this exercise, white and black dots provide the maximum of contrast. Suppose you were to substitute a gray dot for the large white dot. What impact does this adjustment have on the design? Or try substituting a square for one of the dots. The options are endless.

This simple example uses very plain shapes. When subject matter is injected into these shapes, the dynamics of contrast become even more powerful.

Contrast

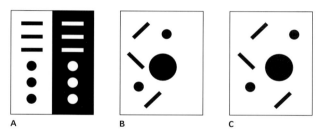

A B C

Simply dividing the format into black and white halves as in example A adds immediate contrast. When one of the elements is noticeably larger than the others, in B, another level of contrast is attained. In C, balance must then be adjusted to accommodate the larger element.

Contrast Can Strengthen an Idea

How can contrast help you strengthen an idea? In certain cases, the use of contrast seems very natural, and hardly requires a conscious decision. Say you were asked to design a poster showing the moon in all its phases. Wouldn't it seem natural to use a dark background behind the moons to allow them to stand out in the format? On the other hand, suppose you were asked to design a poster illustrating for skiers the different runs offered at a resort. Placing the ski runs on a white background would seem equally appropriate. In reality, to do otherwise would be illogical.

These two examples offer simplified solutions, but most problems you'll face as a graphic designer will not be so obvious.

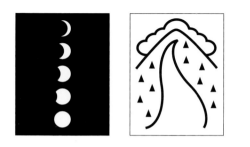

In some cases, the use of contrast is so natural that it's almost automatic. An illustration showing phases of the moon just naturally calls for a dark background to suggest the night sky; an illustration of a ski run seems to belong on a white background, suggesting snow.

For example, I was asked to design a recruitment mailer for Bucknell University (shown on page 106) featuring the idea that students typically are offered two choices when deciding which college to attend. The concept was to contrast a small college setting, with its smaller class sizes and more social environment, with a university atmosphere, which usually provides a broader curriculum and a greater range of student diversity. Bucknell University wanted to show potential students that it could offer the best of both college experiences.

I set up the idea by proposing that the decision of where to attend school might require a student to choose one atmosphere over the other, college over university or vice versa. Thus, the theme of the piece itself provided the initial contrast.

I then divided the format into two halves, one side black and the other metallic blue, to visually communicate that the student has a choice. This contrast of color added visual impact to the design, and the idea was further reinforced by making the decision a multiple choice question, which also ties into the education theme.

But the main point is that the visual contrast, along with the contrast between choices provided in the text, served to strengthen the main idea of the piece. That is, this design was tied directly to the idea that was communicated, and the principle of contrast served to strengthen the idea.

Contrast Can Be Achieved in a Variety of Ways

While design elements are most often used to support the content of the message, a powerful contrast can be provided with the use of contradiction. In the example on the next page, the word *big*, when set in type that fills the format, lives up to its definition. When set in tiny type, *small* does the same. But what if you were to set the word *big* in very small type and the word *small* in type that fills the format? This use of contradiction implies a completely different concept.

There's a classic poster by designer Jack Summerford that simply uses the word *Helvetica* spelled out across the poster in Garamond type. The contradiction of the presentation and content of the word is what makes the idea work. It needs no other embellishment.

When using contrast to express an idea, entertain all the possibilities: contrast may be provided in size, color, shape, texture, typeface and more. Think in terms of large or small, black or white, straight or crooked, perpendicular or angular, thick or thin, smooth or rough, shiny or dull, serif or sans serif, angular or rounded, organized or haphazard, centered or off-center.

But carefully choose the combination that best represents the idea you wish to communicate. Using contrast without solid reasoning can cloud the concept.

Contrast in Value, Color, Shape and Texture

Contrast in value and color are indispensable in your design work. We'll discuss value and color in greater detail at the end of this chapter, but common sense will tell you that a piece without value contrast (such as a gray-on-gray piece) or without color contrast (such as a light-yellow-on-cream piece) may not have the impact that more high-contrast pieces (such as a black-on-white or a bright-yellow-on-purple piece) would have.

Contrast in shape can be used to portray whimsy or to create a somber tone. Who can deny the power of the swastika when it comes to creating an identity, or the variety of emotions it invokes? The hard-edged, spider-like design was the perfect symbol to communicate the intensity of Hitler's vision of the world. In contrast, who can see a 1960s poster of the flower generation and not get an instant feeling from its soft, flowing lines for the carefree attitudes that prevailed in that era?

Similarly, architecture constantly uses contrast in textures to create moods. The contrast of two very different materials, such as shiny chrome against a concrete wall, is intriguing. When you look around your neighborhood, how many combinations of contrasting building materials can you spot? What is the feeling they create? Something as simple as shiny white wood paneling against a brick wall is an example of contrast at work.

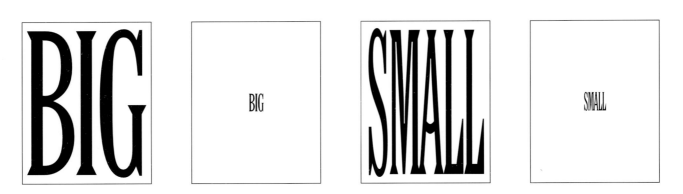

While typefaces are most often used to support the content of the message, a powerful contrast can be provided when the typeface (or size of type) contradicts the content of the text.

Contrast

Contrast in Typography

Typography affords the designer a great opportunity to use contrast.

If you look at any book or magazine layout, you'll see contrast in typography at work: larger headlines contrast with smaller subheads, photo captions and body copy. Contrast in type size can be used to lead the viewer's eye, which is why the headline is typically larger than the body copy, and captions are relatively small compared to both.

If you look at a printed page where the writer is limited to one size of type, the writer will often use boldface, underline the letters, or use all uppercase letters for a headline to make it more prominent. The difference between the normal type and the boldface, underlined or uppercase type is simply contrast.

The designer works in the same way except at a more powerful level, but this power is often underutilized. If your headline is not made prominent enough, you risk confusing the reader and reducing the headline's impact. However, the headline is often purposely underplayed to reinforce the idea. Contrasting typefaces also allow you to add interest to your design. In example A at right, there are three typefaces, consisting of serif, sans serif and display faces, that work well together in different text blocks, such as headlines, body text, pull quotes and sidebars. Example B consists of the same layout using one face for all text blocks. Notice how much more interesting the first example is. This is due to contrast.

There is no rule specifying how many different faces you can use in a single layout. I have seen very successful designs that employed a dozen faces, but using multiple faces successfully is usually the work of an experienced designer. Until you get a feel for what is and is not appropriate, it may be advisable to stick with two or three.

When placing type within a format, ask yourself what you can do with that type to strengthen your idea. Consider contrasting the type size, type style or weight of the type (using book, medium, semi-bold, bold, heavy, black, etc). You may try varying leading (space between the lines of type) or density (space between the individ-

ual characters; tracking or kerning). You may also try different type positions or column widths. Making the body copy large for the sake of readability is fine, but at a certain size, determined only by experimentation, text that is too large can appear awkward and clunky.

Similarly, contrast comes into play with the density of the type. In the example shown on the next page, the same layout is done using different densities of type. In each example the feeling is different. Which is more appropriate to the idea?

Type is a crucial element

Type is a crucial element for any design in which it appears, and it is used in so many designs. Type is perceived by the viewer in several ways simultaneously – as text to read, as shape, and as a purely visual element, in which the letterforms themselves convey a feeling or a meaning. Consequently, learning to use type well is one of the most important skills you can develop as a graphic designer.

When type is used badly, however, it can be so inappropriate to the communication that it interferes with the intended message.

Using type well means using it appropriately to communicate, taking into consideration the various ways it will be perceived by the viewer. When you've used the typeface itself – to visually convey the meaning of the written word that the symbol represents, you've effectively used type to solve a problem. When type is used well, it may even stand alone, without an accompanying illustration or a photograph.

A

Type is a crucial element

Type is a crucial element for any design in which it appears, and it is used in so many designs. Type is perceived by the viewer in several ways simultaneously – as text to read, as shape, and as a purely visual element, in which the letterforms themselves convey a feeling or a meaning. Consequently, learning to use type well is one of the most important skills you can develop as a graphic designer.

When type is used badly, however, it can be so inappropriate to the communication that it interferes with the intended message.

Using type well means using it appropriately to communicate, taking into consideration the various ways it will be perceived by the viewer. When you've used the typeface itself – to visually convey the meaning of the written word that the symbol represents, you've effectively used type to solve a problem. When type is used well, it may even stand alone, without an accompanying illustration or a photograph.

B

Use of contrasting (yet complementary) typefaces in the same design can provide a lot of interest. In many cases, the use of a single face for everything is not nearly as attractive.

A very long, very narrow column of text may annoy the reader by causing the eye to travel back and forth too often to descend the column. Likewise, a column that is too wide can cause the reader's eye to tire, and may make it difficult for her to keep her place in the text. I can't tell you what's too narrow or too wide; the goal is to understand the effect on the reader and to be sensitive to the reader and the written message. In most cases, the conceptual design that works with the written message has a better chance of communicating with full power.

A final caution about contrast: all contrasts do not have to be dramatic. When suitable to the overall message of your piece, diminished contrast—or a more subtle contrast—may in fact be desirable. When going for this effect, make sure that the difference, while subtle, is still discernible; otherwise, it may go unnoticed or—even worse—may look like a mistake. Early in my career I designed a poster for a beauty pageant using a silver line illustration of a crown on a gray background. The desire

was to create an elegant, understated poster that would communicate the sophistication of the event. After the poster was hung, my client paid me a visit to voice her displeasure about the poster. To understand her concern I ventured to a location where the poster was hung, only to see a big gray empty rectangle hanging on the wall— seemingly with nothing in it. The elegant silver lined illustration appeared invisible from any more than just a few feet away from the poster. Consequently, the desired effect of the poster was lost due to the unwise use of contrast in my design.

In summary, contrast enhances our enjoyment of the differences in things around us. Design is merely an extension of everyday life that allows us to communicate visual concepts and ideas to each other. Contrast is a powerful design principle available to distinguish your message.

Ballet

Ballet is a dance in which conventional poses and steps are combined with light flowing figures such as leaps and turns. A ballet is a theatrical art form using ballet dancing, music, and scenery to convey a story, theme, or atmosphere.

Ballet

Ballet is a dance in which conventional poses and steps are combined with light flowing figures such as leaps and turns. A ballet is a theatrical art form using ballet dancing, music, and scenery to convey a story, theme, or atmosphere.

In addition to contrasting typefaces, type sizes and width of text columns, you can also vary the density of type used. Here, the same type layout is done using two different densities of type. Which is more appropriate to the idea?

EXPLORING CONTRAST

Portraying Ideas Through Contrast

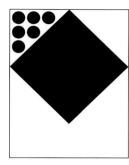

There's almost always more than one way to illustrate a concept, even using the same elements. To convey the idea of "captivity," you might think first of putting the smaller circles into the larger square. But what about showing the circles being crowded into a corner by the square?

This exercise will help you explore the power of contrast in design. Cut one 6" (15.2 cm) square out of a piece of colored paper and six 1" (2.5 cm) circles out of paper of a contrasting color. Create designs on an 8½" × 11" (21.6 × 27.9 cm) piece of white paper to convey the following concepts:

1. Captivity
2. Freedom
3. Love

Since the small circular pieces of paper are in automatic contrast to the single large square (in size as well as color), you will be compelled to find solutions where the principle of contrast guides the design.

For instance, one way to convey "captivity" would be to place the six circular shapes within the square. What other, less obvious ways are there to illustrate the concept of captivity? How about showing the six circles being crowded into a corner of the format by the square?

What happens if you divide the format in half horizontally—the top being white and the bottom black? How does this new contrasting format expand your ability to convey the three themes? Do the shapes take on new meaning as they sit on either the white or the black side?

Now try to illustrate the other two concepts listed above. Are there other concepts you can think of that you could illustrate using these same materials?

What to Consider When Striving for Contrast

1 *Do the contrasts you've chosen for your design strengthen its idea?*

2 *Have you fully considered all the ways you might achieve contrast? Do you want to use contrast in value or color? Shape? Texture? Typography?*

3 *Are your choices of contrast in typography suitable to the message of the design? Does your use of type make the piece more or less readable for your audience? More or less visually appealing to your audience?*

4 *Have you pushed contrast to its most potent level? That is, if you're using large and small photographs, is there enough difference between the two sizes to show an obvious contrast?*

5 *Have you considered the idea of diminished contrast? (Not every successful design uses polar opposites for contrast. Sometimes subtlety can add strength to a design: subtle color shifts, subtle differences in type, etc.)*

Olympic Events Series
McRay Magleby
Magleby and Company

These two posters use the paper they are printed on as a part of the concept. Since the topic is winter sports games, the paper automatically becomes an element, even though it has no texture or color. On the skiing poster, the skis disappear into the paper. The viewer sees snow even though there is none actually portrayed. The ice skater is bearing hard against his skates and you can imagine the surface of the hard ice even though it's not illustrated. All of this drama is due to the contrast of the images against the starkness of the white background. To actually attempt to render snow or an icy surface would have been a mistake. A good designer finds the elements of design that are automatically in place and builds on those. Knowing that these posters would be about winter sports, the designer likely knew that the white paper would play an important part in his design from the beginning.

Contrast

Michael Ray Charles Promotion

Lana Rigsby

Rigsby Design

This promotion, including the brochure, is a classic study in contrast. The cover of the brochure is completely white, except for the addition of some very tasteful red type. When you turn the cover a solid red page with white type meets the eye against a solid white inside front cover. The very next spread is solid black on the left page and solid white on the right. All of the type in the book is played down as the impact of the design is carried by the contrast of the solid-color pages. Even the innovative packaging for this promotion is a stark white sewn envelope printed with black line art. Inside the package, the oversized book showing the artist's work is colorful yet still consistent with the solid black, white and red theme. Not only does this color scheme add power to the design, but it also creates an appropriate forum from which to show the artist's work, which is largely black-and-white illustration.

This elegant solution to promoting Tableaux Restaurant uses contrast and variety to create a sophisticated yet lively look. The mailer, especially, is the epitome of this approach, with its use of different yet complementary images and elements, including a leopard-skin pattern, stylized sun images, metallic bronze with olive green, Chinese type and English with calligraphic flourishes. The address side of the mailer has a high-key value, while the opposite side is low-key. This piece is given special appeal by the use of an unusual shape and die-cut black flaps that lift up to reveal more information printed on a light screen of olive green. The mailer, along with the rest of the identity system, uses three common colors—black, olive green and a metallic bronze—to unify the elements and give a common identity to the campaign.

Tableaux Restaurant Promotion
Petrula Vrontikis
Vrontikis Design Office

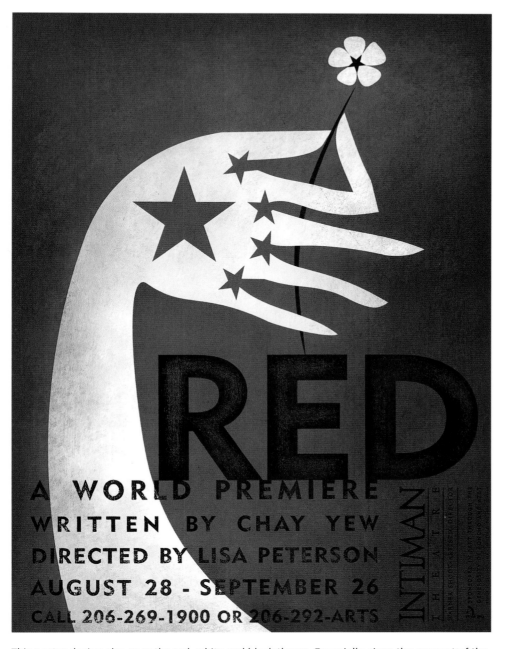

Red Theater Poster
Dennis Clouse
Cyclone Design

This poster design also uses the red, white and black theme. Especially given the concept of the piece, any other combination of color simply wouldn't provide the same effect. The design is basic and the idea easy to understand. As with the most powerful pieces, there is nothing in the design which distracts the viewer from the concept the designer desires to communicate. Instead of using a standard typeface, the type is given a texture that makes it much more interesting. The sans serif type contrasts with the serif typestyle used for the name of the theater. This poster is also a good example of simple shapes working together to create interest.

The cover of this identity guide is completely white with just an embossed logo placed on it. The book is stitched with a quick reference guide that opens on the left side of the cover. The tabs of this reference guide are multicolored in the designated company color palette. As you open the cover, the logo becomes full color and the accompanying brand information is placed on the opposite page on a blue background. The principle of contrast of this piece consists in sol-id color pages placed against solid white or even black pages. This juxtaposition is a part of the concept since an important facet of this new identity is to encourage the company-wide use of the new color palette.

MPI Identity Manual

Nhan T. Pham

Peterson & Company

Contrast

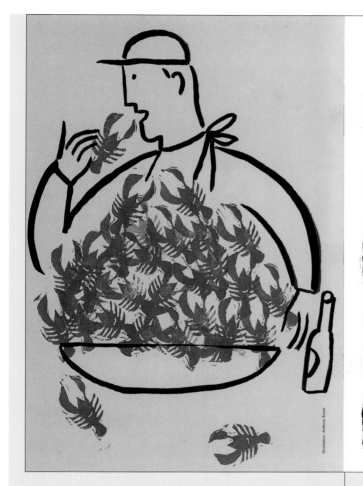

This entertaining spread from *Rough* magazine shows opposing pages that are very active and which look very different from each other but nevertheless work well together. The solid yellow on the left contrasts with the predominantly green page on the right. However, the yellow of the left page is brought into the right side in the corn on the cob. The line quality of the illustration is echoed in the hand lettering. The red in the crawfish is repeated in the type and lip illustration. Especially in editorial design, it pays to try the unexpected. If everything is too logical or predictable, the design will be stilted and uninteresting. As in this design, don't be afraid to take chances.

Rough magazine spread

Scott Ray

Peterson & Company

BUCKNELL

CONTRADICTION

A

DO YOU WANT A LIBERAL ARTS COLLEGE
Is it A? Do you want the benefits of
a strong liberal arts college
where you'll get personal
attention from faculty com-
mitted to teaching, where small
classes encourage you to excel,
where you'll find your own special niche?

OR

...OR A COMPREHENSIVE UNIVERSITY?
Or is it B? Do you want a compre-
hensive university that gives you
extensive academic choices in
liberal arts, engineering, and
other professional fields? Do
you want to study with respected
scholars as they explore new ideas?

B

The concept behind this piece is that students typically have two choices as to what kind of edu-
cational experience they want from a college: a small liberal arts college or a larger university
with more academic choices. This brochure promotes Bucknell as a place where students can
have the best of both worlds. Because the heart of the concept is a comparison between two
very different choices, contrast plays a natural part in this design. By giving each choice a dis-
tinctive look, the concept is easily communicated. Contrast is provided throughout the layout,
with the two sides of each spread using elements that are direct opposites of one another. For
example, one page has a dark background, the facing page has a light background; one typo-
graphic page is exactly the opposite color of the page facing it. Despite these contrasts, there is
also a certain amount of unity in the design, supporting the idea of Bucknell as a college that
offers students the best of both educational choices. For example, the same typefaces are used
on both sides of each spread, and shapes and words often continue uninterrupted (except by
color changes) across the gutter. The horizontal format allows the design to be broken in half
vertically, still leaving enough room to develop the graphics.

Bucknell University Promotion
Bryan Peterson
Peterson & Company

This annual report is a study in contrasts. Immediately obvious is the use of the ultimate contrast in values: mostly pure black and white, relieved with some gray. The images include high-quality photos containing the same stark contrasts as the rest of the design. One example is the series of photos of the Earth taken from space, emphasizing the small, life-filled globe contrasted against the vastness of space. The typefaces present another contrast: a heavy sans serif face is combined with a delicate serif face. The booklet is beautifully paced, with both key bits of textual information and images allowed plenty of breathing room on the page. Other elements at work in this piece are the textures in the photographs, as well as the texture of the financial paper. The book is balanced on an implied horizontal axis that begins on the cover and runs through the center of the design on subsequent spreads.

Earth Technology Annual Report
Lana Rigsby
Rigsby Design

This beautiful book is loaded with vitality. Every spread contains a new surprise or visual treat. While the design is rich in contrast of lights and darks, the book contains more creative contrasts. Notice how the type on the title page contrasts with the rich fabric design on the page across from it. Another example of contrast in this book is in the juxtaposition of color photos with black-and-white pictures, as in the examples to the right. Type on the various spreads may be small or it may be displayed large. In several spreads, while the left side is busy, the right may hold just one image that swims in white space. All of these treatments make the book layout come alive.

Hillbilly Hollywood Book
Sharon Werner
Werner Design Werks, Inc.

Unity

Y

ou've heard the expression, "The whole is greater than the sum of its parts." I've heard that said of the legendary rock band, the Beatles—individually they were never as great as they were together. Likewise, in a single design, it's possible to use each available element (line, type, shape and texture) independently, but true power lies in the skillful coordination of these elements.

In fact, multiple elements in a design will necessarily work either with each other, providing a unified whole, or against each other, leaving the design with a disjointed feeling. Even if individual elements are suitable independently, they may not be suitable together. Unity—the coordination of design elements so that each works well with the others—plays a fundamental role in any design.

Achieving Unity With a Grid

As you look at your house, you may not be aware that there is a framework of materials—maybe concrete or wood—that is supporting walls, floors and ceilings and providing an underlying structure. Similarly, as you look at a successful design, you may not be aware of its underlying structure, but it is as important to the success of the design as the framework is to your house. In design, this structure is usually called a grid.

Books, magazines, brochures, newsletters and other multipage documents are rarely built without the help of a grid. A grid can provide unity in a variety of ways: through the use of a consistent border, a set column width for type, the same space between columns, a consistent size of text type, a common position for folios (page numbers), and a common opening layout for different sections.

When a grid is functioning successfully, the reader gets the feeling that the design is working together from page to page. The importance of this underlying structure in creating unity in a design can be discovered using the following example.

A Simple Grid

Using three circles and three squares, I've created a different design on two different formats without the use of an underlying grid. (By virtue of my use of common shapes, I have achieved some degree of unity in the layouts, even without the use of a grid.)

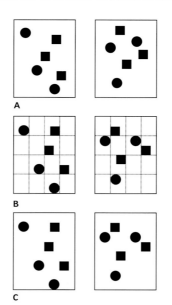

A

B

C

A simple grid can provide consistency between pages of a design. In example A, elements are placed into two different formats at random; no underlying grid is used. In B, these same elements are arranged in a more orderly way with the help of a visible grid. Finally, in C, this grid is made invisible, and the elements are left in place. Notice how the layouts in C are more consistent with one another than those in A.

Now let's take the same format and apply a checker-board-style grid that divides the space into four horizontal and four vertical sections of equal size. Let's place the circles and squares in the four new formats, lining up the edges of each object with one of the given grid lines.

Now make the grid invisible and compare the two sets of two layouts. Notice that the layouts in the second group appear more consistent with one another—a result of the underlying structure.

When to Break Out of the Mold

You might also notice that the second group of formats doesn't have quite the spontaneity or visual intrigue that the first group has. This is also a result of the grid we've established. Grids, when followed tightly, function to unify the basic design—sometimes at the expense of the designer's freedom of expression.

Once this basic structure is in place, the creative designer can strategically break out of the grid to give the design vitality. But this must be done with some thought, or it can be overdone, weakening the grid's usefulness.

Grids may be very simple (with only a few set areas specified) or very complicated (with a predetermined placement for every element). But whether simple or complex, you must decide how strictly to adhere to grid lines; this adherence can range from very strict to very loose.

If you're a beginning designer, you may want to start by using a fairly tight grid, or one that strictly guides a placement for most of the elements on the page. This will help you achieve a feeling of unity—thus ensuring a more professional look for your piece. After you gain experience using a tight grid, you can begin to experiment with elements that purposely violate the grid, or a more complicated grid that gives your elements more options for placement. As mentioned earlier, this is where you will achieve the most vitality in your design.

When Do You Need a Grid?

Unity can be achieved without the use of a grid. A poster, for example, or a single-page document would not benefit as much from a grid as would a multipage piece. Even so, it's possible to establish a grid for your poster if you want to, and it may in fact be useful if you're juggling a lot of different elements.

The example below shows a poster where the intent was to display a variety of logos. By virtue of the simple underlying grid, the poster feels organized. Would it be possible to do the same poster without an underlying structure? Yes. A random placement of logos, perhaps even tilting the logos at different angles, would achieve an entirely different feel. But this randomness might detract from the point of this particular poster, which is to feature the logos themselves as the main attraction.

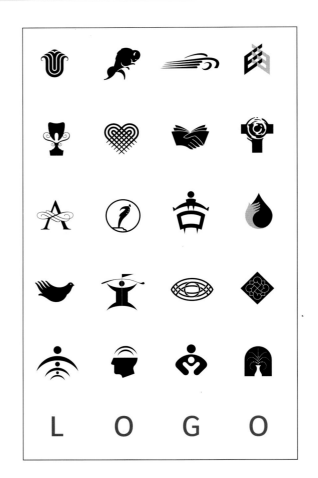

This poster displays various logos designed by Nhan T. Pham of Peterson & Company. By virtue of the simple underlying grid, the design feels organized, even though it's composed of a lot of little elements that are otherwise unrelated.

Unity

Unify Your Design Using Similar Elements

How can you unify your design without the use of a grid? One way is by using design elements that are already similar. In the example below, the design uses line and type. Each element of line is different by virtue of weight and color. The elements of type are also different styles and sizes. It would be possible to make all the lines the same weight, length and color, and all the characters of type the same size and face. By doing this, you've automatically unified the design without repositioning the elements themselves. But, if taken to this extreme, you've almost certainly created a design with less visual appeal, since you've diminished the equally important principle of contrast.

Instead of making all the lines identical in every respect, try unifying just one aspect of each line, perhaps the weight. Instead of using type of the same style, size and weight, try unifying just the type style. You will have achieved a good deal of unity without taking away the individual identity of each element.

Leading the Eye Through Different Elements

Just as an architect uses careful placement of doors and walls to lead the flow of traffic through a space in an optimal fashion, so does a designer use careful placement of design elements to lead the viewer's eye through a piece. A design that fails to do this runs the risk of disrupting the communication of the concept.

The tools that will help you effectively lead the eye include the position of the elements and their relative size, subject matter, and value or color.

To demonstrate this, let's consider an example in which some of these factors interact to cause the viewer to see elements first in one order and then in another. The illustration on the next page uses three elements: a shape, headline type and text. In the first configuration, the elements are placed randomly on the format. The shape, by virtue of its size, commands the most attention—so this is where the eye enters the design. But this might not be what you want if, for instance, you're designing a poster and need to have the reader notice the headline first. Is it possible, using these same elements on the format, to persuade the reader to read the large type first?

The second configuration demonstrates that, when you place the headline type within the shape, the shape tends to act as a frame on a painting, taking second place behind the type and guiding the eye to the type instead of the shape.

What happens when you place the text type inside the shape as in the third example? The shape now becomes the last element to command attention. We have successfully led the eye of the viewer.

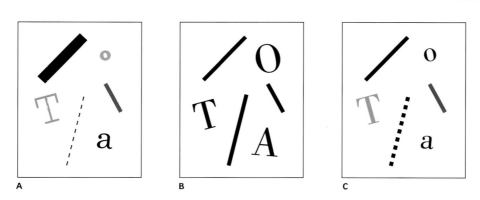

A B C

Using similar elements is one way to unify a design. In example A, each line is different from the others by virtue of weight and color, and the elements of type are also different (varying in size and style). In example B, all of the elements have been unified by making lines, type and other elements all the same in every possible way. In example C, a happy medium has been reached, with lines that are all the same weight but different lengths, and with type that's all the same style, but of different sizes and weights.

Unity

Leading the Eye Through Similar Elements

An important part of effective layout is knowing how to lead the eye through your design even when the design consists of similar elements. Suppose, for example, you have four photographs that are different in content but that have roughly the same mass.

In the three formats on the next page, the four photographs are represented by dots. These shapes are placed in different positions to demonstrate how you can lead the eye. When you add subject matter to the photographs, you increase the ability to control the eye. But for now, let's just examine how these various placements will lead to different "readings" of the same elements.

In the first example, by isolating one of the shapes and grouping the other three together, you automatically cause the eye to begin with the isolated shape. In this way, you lead the eye to discover the contents of the isolated photograph first.

In the second example, three of the four shapes (or photographs) fall within a grid, and the fourth falls outside the grid. This is similar to the treatment in the first example, in which one of the shapes is set apart from the other three. This, likewise, causes the eye to single out the element that's set apart: the one outside the grid.

In the third example, the four photographs are placed in a line. Because we are conditioned to read left to right, the eye will almost always begin at far left and proceed to the right with visual elements as well as with words.

These examples are simplified, of course, but still help to demonstrate basic ways you may begin to lead the eye of the viewer, which is always required in constructing an effective design.

This same concept also works with the elements of type, line and texture. In fact, if you have this much control over the attention of the reader with the use of similar elements, imagine what you can do as you introduce elements of different size, color, position and subject matter into the design. In the hands of a skilled designer, the principle of unity is a significant asset.

If this principle is ignored, a lack of unity and "eye control" can confuse the reader and muddy the concept of your design. Experiment with such things as the subject matter of each photograph, the intensity of the image, the contrast of each image in relation to the others, and the color of the subject matter in each photograph. The possibilities are endless. You will discover a new power in your work as you gain skill in controlling the unity of your design.

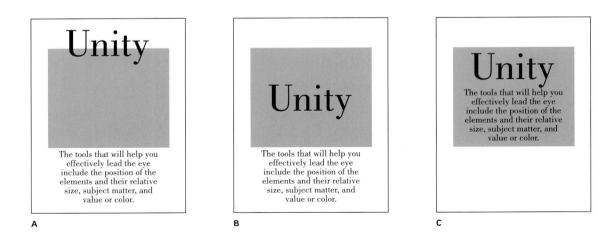

A B C

The placement of elements is one factor that determines the order in which the eye perceives them. In example A, the elements are placed at random in the format. By virtue of its size, the shape draws the eye first. In B, placing the headline type within the shape causes the eye to go first to the headline, then to the shape, and finally to the rest of the type. In C, the eye goes to the shape last, simply because of the way it's placed in relation to the other elements.

Unity

Unity Versus Contrast

Earlier, we discussed the importance of contrast. Often, the more "the same" something is—for example, the tone of a voice—the more monotony you experience. So unity is important, but not at the expense of contrast, which provides interest.

Achieving an appropriate balance between unity and contrast is a tricky and sensitive issue. On one end of the scale you have pure contrast, which might be defined as chaos, and on the other hand, complete unity, which might be defined as sameness to the point of boredom. As you gain experience with design, you will find that magical balance that allows your design to maintain interest without feeling unconnected or fractured.

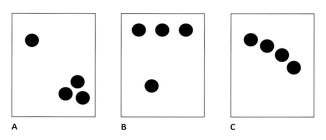

A B C

The eye can be led in a particular order even with the use of similar elements. In example A, one of the shapes is isolated from the other three, causing the eye to go there first. In B, three of the four shapes fall within a grid, and the fourth falls outside of it. Where does your eye go first in this case? In C, the shapes are arranged in a line, causing the eye to "read" them left to right.

What to Consider When Striving for Unity

1 *Does the design you want to do call for a grid? (For most multipage documents, a grid is probably necessary; single-page documents may or may not benefit from a grid.)*

2 *How complex will your grid need to be? What elements will be consistently placed according to the grid lines?*

3 *Where might it benefit your design to break the grid? When you look at pages where you've broken your grid, do they still seem connected to the pages where your grid is intact? (If not, consider whether you've been too free in breaking your grid.)*

4 *Have you been able to achieve unity through the use of similar elements? Do your lines, blocks of text copy and other elements on the page look as if they belong together in some way?*

5 *Does your design lead the eye? Is there an obvious place in your design where the eye enters and then travels through the elements?*

6 *Have you eliminated any elements that distract the eye and pull it away from important parts of your design?*

EXPLORING UNITY

Using a Grid

Strongly related to the concept of unity is the idea of a grid system. A grid is a structure upon which elements can be placed in an orderly way. A grid is usually employed to lie behind the design—and is usually invisible in the finished design. Most publications are laid out with a grid system; if this grid is noticeable, it becomes a design element. With the use of a simple grid, you can build a design that feels cohesive.

On a white piece of 8½″ × 11″ (21.6 × 27.9 cm) paper, draw a vertical line 1¼″ (3.2 cm) from the left margin and another six vertical lines 1″ (2.5 cm) apart, starting from the first vertical line you drew. Following the same procedure, draw a horizontal line 1½″ (3.8 cm) from the top margin and eight more horizontal lines 1″ (2.5 cm) apart, starting from the top horizontal line and working downward (as shown top right).

Next, cut six 1″ (2.5 cm) squares out of black or colored paper. Then cut two 2″ (5.1 cm) squares and one 4″ (10.2 cm) square out of the same paper. Using all of these squares, arrange them on the grid in as many configurations as you can dream up. Be imaginative!

Because of the underlying grid, and because you're using elements that are similar (all the shapes are square, although they are different in size), you'll notice a certain cohesiveness as you place these patterns side by side. These patterns might be considered to be simplified pages of a multipage document, since they share an appropriate unity in their design.

Three examples are shown at right.

Create this grid in the following way: on a white piece of 8½″ × 11″ (21.6 × 27.9 cm) paper, draw a vertical line 1¼″ (3.2 cm) from the left margin and another six vertical lines, each 1″ (2.5 cm) apart. Next, draw a horizontal line 1½″ (3.8 cm) from the top margin and eight more horizontal lines, each 1″ (2.5 cm) apart.

Here are three sample design "pages" that can be created using the grid you just made and nine color squares (six 1″ (2.5 cm) squares, two 2″ (5.1 cm) squares and one 4″ (10.2 cm) square). Because of the underlying grid, and because the elements are similar, any pattern you create in this way will have a certain cohesiveness with any other pattern made the same way.

Unity

Art Real Promotion
Brian Gunderson
Templin Brink Design

This refreshing identity system is a perfect example of unity. As one scans the array of designs it is obvious that there is a theme, but each piece is not a duplicate of the next. Each, instead, takes the look to a different corner and adds a new level of diversity. Certain elements remain constant. One of those is the color palette of yellow, blue, green and black. Another is the choice of typeface. A third might be the use of white space on each card; the ratio of color and type to white space is about the same on each piece. The challenge for most designers is to be flexible enough with formats to not automatically shoehorn each part of the identity into the same look. While this ability is one that takes skill, once you recognize the possibility of doing this, a whole new level of design becomes available to you. Once again, the secret is to make certain elements common from piece to piece and allow others to change.

"I saw that in a dream," she recalled

Uncannily.

Michael Graves Design™
Stainless Steel Watering Can $29.99

"I propose a toaster," she announced

Crisply.

Michael Graves Design™
Chrome Toaster 29.99

"Just look what I bring to the table," she boosted

Saucily.

Michael Graves Design™
End Table 69.99

Nowhere is unity more important than in an ad campaign. Creating unity is a form of branding; you must establish a look and attitude that are recognizable even before the content of the ad is read. This particular campaign for Target works quite well in this way. The design is fresh and attention-getting. As simple as the idea is—combining related objects with images of the products the ads feature—it is sure to get noticed because it is also playful. Too often, the tendency is to take our assignments so seriously that we forget the value of whimsy and entertaining design in making customers feel good about the products we are endeavoring to sell. Another nice feature of these ads is the treatment of the type. Not only are the headlines clever but the type is tastefully applied to the ad. It is interesting that the Target nameplate does not exist anywhere on the ads. The symbol is enough to identify the store.

Target Ad Campaign

Gaby Brink

Templin Brink Design

In this piece, the calligraphy alone is elegant enough to carry the identity from one piece to the next. But the designer had the determination to take it beyond the ordinary and add other elements that complete the look. The yellowing look at the edge of the pieces gives the design a classic feel. The use of a stamp adds yet another dimension to the pieces. A contrasting black bar that houses the type provides an attractive contrast to the design. Most importantly, the solution for each piece is different from the piece before, which gives the identity an unpredictability that keeps it interesting.

Vignette Identity
Dennis Clouse
Cyclone Design

Unity

This self-promotional gift package consists of lots of bits and pieces—washers, bolts, wooden parts, twine, pipe, glue and even feathers—which the recipient is encouraged to use in constructing a toy. The challenge with this piece was twofold: first, the design needed to create a feeling of unity among the many different (but interrelating) pieces to be used in constructing the toy. Second, the entire three-dimensional package needed to feel unified and related to its contents. What is especially enjoyable about this piece is the sheer diversity of the elements. Unity is achieved in that all of the pieces provided are compatible enough in size and structure that they may be put together to create something. For example, this piece wouldn't work if the apparently random elements were truly random—to the point that they couldn't be joined together. (Think of the confusion if all of the nuts provided were too big for all of the bolts.) In a way, this piece is the epitome of the design process: elements that might appear on the surface to be unrelated are gathered and combined in a format (in this case, a cylindrical container) to give them a kinship.

VWC Christmas Promotion
Rick Vaughn
Vaughn Wedeen Creative

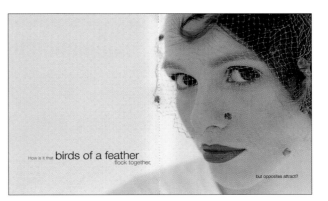

Although extensive in design, this promotional piece for a paper company holds together well, thanks to several unifying elements. One of those is the treatment of the type. The designer uses a single font family throughout the book. There are several sizes of type in different weights, but the single font creates a unified, connected look. Another unifying element is the treatment of the photo images. Photographs appear only in three ways: single-page bleeds, double-page spread bleeds, and single-page photos contained within a border of white paper. The third unifying element is color. Most of the type appears in either black ink, reversed white or red accents. Every now and again the type is used as a design element. In those cases it takes on whatever color and form is appropriate to the design.

Strathmore Elements Promotion

Lana Rigsby

Rigsby Design

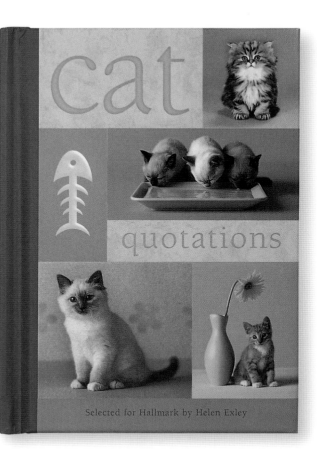

Helen Exley and Hallmark Books sell these books on the same shelf as a part of a much bigger selection of books. It was important to Hallmark that the books have their own appeal and identity while maintaining a visual consistency from book to book. The type treatment and basic design of the covers is identical. But what gives the books their individuality is the content of the photos, the color palette that is used (although the teal green remains consistent), and the typeface selection. The key to successfully unifying a series of books like these is to create a format that is not so restrictive that you cannot give each book its own identity.

Hallmark Books

Miler Hung

Peterson & Company

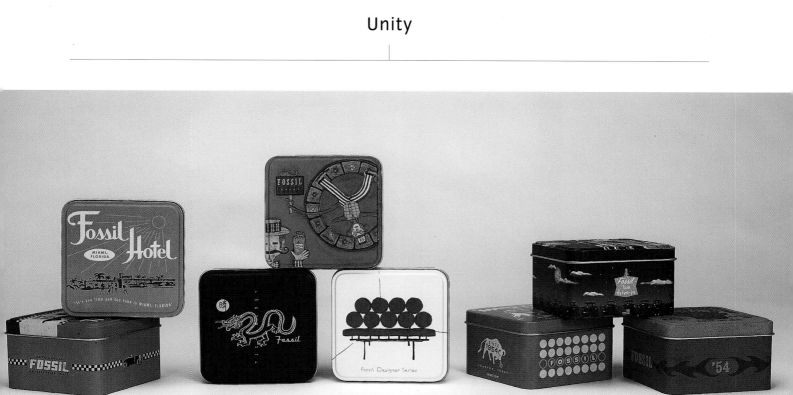

By virtue of similar formats (the container), these wristwatch cans are automatically united. The challenge is to give each can its own individuality while pushing the envelope on great design solutions. This is one of those projects that designers lust after—but not every designer would be as capable as these Fossil designers at portraying the Fossil image of nostalgia so effectively. Each design is a treat unlike the one before. It is gratifying to know that the designers design whatever is necessary to communicate a particular theme, and are not persuaded to unnecessarily complicate the design. If a box yearns for many colors, then it is designed as such. If it is more effective as a two-color tin, then that is the final result.

Fossil Product Cans

Various designers

Fossil

This identity system is refreshing because it is so unexpected. Each piece uses a different type of paper stock, but by virtue of a common type treatment they become compatible and even intriguing. This collection is a great example of how a single element (such as a type treatment) can unify disparate pieces. A less sophisticated designer might have succumbed to the temptation to put every item on a similar paper stock. Once again the lesson to be learned is that the most powerful innovation lies in the simplest of ideas. Properly executed, these simple ideas seem very clever. As you design, force yourself to think of the unexpected. Don't be afraid to consider the unorthodox.

Joanie Bernstein Promotion
Sharon Werner
Werner Design Werks, Inc.

Value

earlier we covered the different elements—line, type, shape and texture—that you can use in a design, and then we discussed some of the design principles—balance, contrast and unity—that help you organize these raw materials. To add dimension, mood and depth to your designs, you also need to understand the principles of color and value. Since value is intrinsic to all design but color is not, we'll discuss value first.

Value Is Inherent in Any Design

A successful design generally works well in black and white; color shouldn't be used as a crutch to prop up an otherwise poor design. Unlike color, value is inherent in a design as soon as any kind of image is placed in the format. You might think of value as an automatic ingredient, like contrast.

What is value? It can be simply defined as the relative lightness or darkness of an object. Let's examine how value works in everyday life and then apply those same principles to value in design.

Value Works in Nature

There are many examples of value at work in our everyday life. For instance, you will find value present in nature to great effect. Imagine yourself in the thick of a dark forest; everything around you is in the shade of the trees, but looking ahead you spot a clear meadow shining in the sun. Your eye is immediately drawn to this clearing because of the striking difference between shade and sunlight.

Additionally, many animals and insects utilize value as a defense mechanism: by assuming colors in shades that are similar to their environment, they protect themselves against their natural predators. (Most camouflage relies on color as well as value, but even the proper color wouldn't hide the animal unless the value was right, too.)

Value Can Be a Powerful Influence

Man is also adept at using value when it serves a specific purpose. Think of the way a white wedding dress—particularly next to the dark suits of the groom and ushers—gives emphasis to the bride. And it was no arbitrary decision during World War II to paint Navy battleships gray; this color was discovered to be the most effective at concealing ships from enemy aircraft.

Despite these examples from nature and human endeavor, designers often fail to recognize that the skillful manipulation of value can actually make their design elements come alive.

As a final example of the great importance of value, imagine you are in charge of putting on a fireworks display. You purchase the best fireworks you can find and assemble a large crowd to watch them explode. The only problem is you select the middle of the afternoon to stage the event. As each rocket explodes in the sky you hear the boom and see the smoke, but the major effect is gone. The night sky would have provided a background of the right value to contrast with the fireworks.

Value

Effective use of value in a design is like the addition of the black sky in a fireworks show: it allows the viewer to see the design elements at their full potential.

All Elements Have Value

Any element added to a format automatically brings value with it, since every element you deal with contains a degree of value, anywhere from 1 percent to 100 percent black. Of course, that assumes a white or gray background. If your background is completely black, any elements you add will be between 1 percent and 100 percent white. This fact implies another quality of value: Value is relative.

Value Is Relative

Every element that can be seen with the naked eye, such as a light-gray box on a white background, is already using the principle of value. The value of something (the gray box) is relative to the other elements near it and to the background it's placed on (the white background).

The greater the difference in value between the object and its background, the greater the contrast. So value is related to contrast, but it isn't the same thing. You can achieve contrast without value (for example, by using varying shapes or textures), but you can't have value without contrast. The contrast may be great (black on white)

or small (similar shades of gray), but it will be there.

Since value is such a powerful influence on the feel and mood of a design (whether it's done intentionally or unintentionally), your goal should be to learn how to use value intentionally to create the strongest possible design.

The skillful use of value in your designs will add power and appropriateness. The example below shows the impact of a single element placed into the format in three varying shades. None of the three can be called the correct value, since what matters most is the desired effect.

But it is correct to say that values can be used to establish contrast, or the opposite: a subtle blending of shades. What differences in mood are created when the values create a strong contrast? The more stark the element is against the background, the bolder the statement. On the other hand, a softness is created—in either high-key (light tones) or low-key (dark tones)—by using subtlety in value and minimal contrast. Therefore, a design is considered either high key or low key. A low-key design consists of a composition where the predominant elements are dark in nature. You may have an element or two that are in contrast to the rest, but the majority of the elements provide a dark feeling for the design. Similarly, a high-key design is one where the elements are primarily bright—either in color or in value. Once again, this does not mean the design lacks contrast. There might be a single element that is black—but it will be set against a design that is mostly light in value.

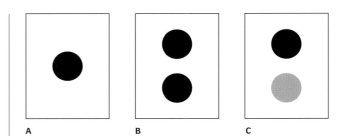

Notice the different impressions created by a single element that's placed in the format in three varying shades, or values. The "correct" value is the one that gives the desired effect for a particular design.

A black dot placed on a white format creates a sharp contrast (example A), but the design is static. When a second dot of equal value is added, as in B, the two elements share equal importance, but the format remains static. When a second dot of a different value is added, however, you begin to see movement and direction created through the use of value (example C).

Value Creates Movement and Direction

When a black dot is placed on a stark white format, as in example A on the previous page, the contrast in value is great and the dot is very prominent. When this element shares space with another like element, as in example B, it also shares equal importance. But make one of the elements darker than the other as in example C, and you begin to create movement and direction.

When the format is flooded with elements of equal value, as in example A in the illustration at right, they will share equal prominence. This can create a feeling of sameness. When the elements in the format are of different value (example B), you begin to create movement through value. For example, when you place the dots in a specific order, their value leads the eye in a certain direction, just as you can lead the eye using shapes and other elements by placing them in a pattern. Notice how the design is given movement and direction when the dots are placed in a pattern according to value (example C). The eye tends to go first to the shapes that have the most contrast.

Value Can Create a Mood

No other principle of structure has more power to create a mood than value. With the effective use of black, white and gray values you can add power or change the mood of a design. Consider the classic design of the Beatles' White Album. The cover consists of a sea of white with the small word *Beatles* embossed on the front; the only value is the slightest hint of shading where the embossed letters cast their shadow on the pure white background. In a time when many album covers were being designed to excess with the 1960s genre of psychedelic art, this simple cover, with its very restrained use of value, was full of impact—yet extremely simple. This was accomplished through the clever use of value.

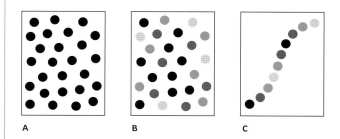

A B C

When a format is flooded with elements of equal value, a static feeling of sameness can be created (A). But introduce just a few elements of differing values, and you begin to create movement (B). When these elements are placed in a specific order (as in C), you can actually lead the eye using value, just as you lead the eye using shape and other elements.

What to Consider When Using Value

1 *Have you really chosen the values present in your design? Or have you allowed values to present themselves as they will, without careful use and manipulation where necessary?*

2 *Have you intentionally chosen values that provide contrast? Is this contrast appropriate to the idea of your design?*

3 *Have you intentionally chosen values that are very similar to provide a subtle, or blended, effect? Is this effect appropriate to the idea of your design?*

4 *Does value help move the eye through your design? (Keep in mind that the eye tends first to go to shapes that have the most contrast.)*

Color

Once you're comfortable with value, you can begin to appreciate the added dimension of color. You have considerably more power to create a mood when you can not only decide on the intensity of the shade of an element, but can also determine the color. These decisions require great care to ensure the success of the design.

Color Can Override Value

Below is a continuation of the set of examples in the section on value (page 125). Introduce into this same format a single red dot.

Suddenly this dot is the center of attention. If this design were to be converted into a black-and-white design, the red dot would become gray, which, while having some contrast to black, would still tend to blend into the design. But by virtue of its color, the red dot becomes the focus. This simple example illustrates an important concept: color has the power to override value and change the intent of a design. For this reason, color must be used carefully so as not to lead your design astray from its original intent.

Intrinsic Properties of Color

Using color as a design tool is largely a matter of taste. We make color decisions every day about our wardrobe—being careful (or not, depending on our intent) to wear appropriate color combinations. While there are no hard-and-fast rules that dictate which colors go together, there are certain unchanging properties of individual colors. Knowing these properties can help you decide when to follow the rules, when to bend or break them, and when to ignore them completely and come up with new ones.

Warm and Cool Colors

The color wheel on the next page shows colors arranged in the order of the spectrum; red, orange, yellow, green, blue and purple. If you start with red, the warmest color, the remaining colors in the wheel follow in order and become increasingly cooler until you reach blue, the coolest color. All colors can be classified as either warm or cool. Warm tones lean to the red, orange and yellow side of the color spectrum; cool colors lean to the green, blue and purple side.

One quick way to understand warm and cool colors is to begin with a flat gray; that is, a gray that has no color pigment, but is just a shading of pure black. Using a common no. 1 pencil, create two blocks of shading that are medium gray. Then, using a red pencil, shade very lightly over one block of gray. Using a blue pencil, shade over the second block of gray. Note how this minor modification of the gray boxes has made one warmer and the other cooler.

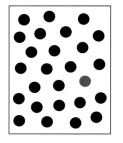

As a demonstration of how color can override value, consider this format—it's identical in every way (but one) to example A on page 125, which means the entire format is filled with dots of equal value. But one of the dots is red, so your attention immediately goes there first. Notice how the value of this red dot hasn't changed—it's only the change in color that draws your attention.

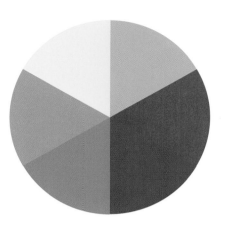

The color wheel is a great tool for understanding color theory. In it, the colors of the spectrum are all arranged in order, from the warmest color (red) to the coolest color (blue).

Even shades of white and black can be classified as warm and cool. For instance, the white paint on your wall may actually contain just a hint of yellow to create a warm off-white. Your computer screen by its nature emits a cool-blue white.

Complementary Colors and Neutrals

All of the colors we've just discussed are either primary colors or secondary colors. The primary colors—red, yellow and blue—are not created from blending other colors; thus, they are primary. The secondary colors—orange, green and purple—can be created by blending together two of the primary colors—red and yellow to create orange, for example.

Complementary colors consist of a primary color and its secondary color counterpart (the secondary color just opposite that primary color on the color wheel). For example, purple complements yellow, orange complements blue, and green and red are another pair of complementary colors. These complementary colors will usually work when coupled, but these combinations are considered very basic and somewhat unimaginative when used in their purest form. Some of the more unusual color combinations provide the most interest.

In addition to considering whether colors are complementary (opposite on the color wheel) or similar (close together on the color wheel), you'll want to be aware of which colors can be used as neutrals.

Beyond the obvious black, white and grays, several other colors can be considered neutrals because they merge well with various color palettes. For example, red, although a strong color, can also be used as an accent color (or neutral) with either warm or cool tones. It will go equally well with an olive green or a slate blue. Yellow is another color that can serve as an accent with several different color palettes. Because red and yellow are also bright accent colors, as well as warm colors, they are sometimes referred to as adopted neutrals.

Color is Present in Black and White

Pure black and pure white exist only in theory. In actuality, when present as an aspect of material objects, every shade of value, even if it appears to be simply black or white, actually contains some color.

In fact, the ability of a pigment to reflect light is what gives the pigment its color. Black absorbs most of the light that hits it; the less light the black reflects, the blacker it appears. White, however, reflects almost all light and therefore appears white.

A white sheet of paper is intentionally milled to be either a warm white or a cool white. A cool white image can be placed on a warm white format to create a subtle white-on-white effect.

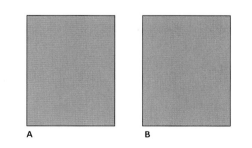

A flat gray shaded over with red takes on a slightly warmer tone in example A, while the same flat gray shaded over with blue takes on a slightly cooler tone in example B.

What to consider when using color

1 *Do the values in your design work, or is color being used to "save" a poorly conceptualized design?*

2 *Do the colors you've chosen support the idea of your design or detract from it?*

3 *Is your design predominantly warm or cool? Would a predominantly cool color scheme be enlivened with warm accents (or vice versa)? (Depending on your concept, this may be an appropriate way to add interest.)*

4 *Have you considered an appropriate use of neutral colors in your design?*

5 *Would your design work better with the full brightness of color, with grayed tones (colors with the addition of black), or with pastel tones (colors with the addition of white)?*

6 *Would your design be more visually pleasing by using color sparingly, as sharp accents? Do you have a design that would actually work best in black and white?*

7 *Is the color palette you've chosen limited and repeated throughout the design? (Unity is sometimes achieved by repetition, including a purposeful, thought-out repetition of colors.)*

Grays, Grayed Tones and Pastels

Grays can also be warm or cool, and these subtle variations can create interesting moods, especially when combined with other colors. Similarly, black is able to produce one mood when combined with dark, rich colors and another when coupled with bright, iridescent colors.

Finally, primary or secondary colors may be altered with the addition of some black (creating more subdued, "grayed" tones), or they may be softened in an entirely different way through the addition of some white, creating pastels.

Experiment With Color

Where can you go for color inspiration? Hypothetically, all of the best combinations of color exist in nature. Train yourself to be sensitive to color combinations all around you. Look at fish, birds, insects and animals, as well as observing all kinds of plant life. When you see a unique combination of colors—whether subtle or bright—ask yourself why that color scheme works and try to analyze it in terms of the color wheel.

Using your computer's color monitor is an easy way to experiment with color. Keep in mind, however, that the colors shown on color monitors rarely match process or match colors exactly, so what looks good on screen may not look good on press.

Pantone and other ink guidebooks are used in the industry as the ultimate guide to how the color will look. Use these books to determine exactly what color you want, but always take into account that most inks, with the possible exception of opaque and silkscreen inks are translucent and will assume the color tone of the paper on which they are printed. Inks that are layered will often create interesting, however, unpredictable third color combinations.

Once you have explored the potential of value, add color to complete your design. You will find that your design immediately takes on added life and power. But be careful not to rely on color in an attempt to rescue a design that needs further conceptual work. Once you have a strong concept and have organized your elements well, the appropriate use of color can breathe life into your design and help it reach its full potential.

All colors are influenced by the colors placed around them. For example, black can produce a dark and moody quality when surrounded by dark, rich colors, but a bright and festive quality when surrounded by bright, iridescent colors.

EXPLORING COLOR AND VALUE

Color Changes Everything

Effectively manipulating color and value can have a powerful effect on your design. Always keep in mind, however, that while color and value have the ability to enhance a strong concept, they rarely have the ability to rescue a weak one.

There is no particular concept at work behind the simplified "design" repeated in this exercise. I've merely created a grid of 20 circles encased by 20 squares to serve as an unobtrusive backdrop for experimentation with color and value.

You can create the same format by drawing a grid and tracing a circle in each square. You'll also need a number of colored pencils; as a minimum, choose black, medium gray, red, orange, yellow, green, blue and purple (these last six represent all the primary and secondary colors).

Begin by using only the gray and black pencils; that is, try some experiments using value only before introducing color. First try creating a high-key design (one that is composed mostly of white or gray).

Next try a low-key design (mostly black or gray). Can you lead the eye through each design, using value only? One tactic might be to place a limited number of white (or black) dots in strategic locations in the design.

Next, introduce color into your design. What effect do you get when you mix black, white and gray dots and squares with colored dots and squares? Try keeping the squares gray and applying color only to the dots. Further experiments might include (1) a design using only primary or complementary colors, (2) a design using only three colors that are adjacent to one another on the color wheel, or

(3) a design consisting only of colored dots, each placed on a square of a complementary color.

These examples provide only a few of the infinite possibilities when mixing color. If you began to use colors that are blends of the colors on the color wheel, or pastels and other more subtle colors, you could spend hours creating interesting combinations even with a design as simple as the grid in this exercise.

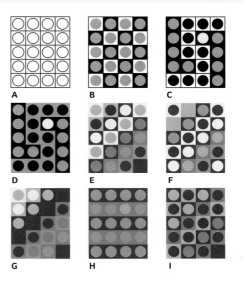

A single design grid can change considerably, depending on the use of color and value. The basic grid (example A) is turned into an example of extreme contrast using only black, white and gray (example B). Using these same values, it's possible to lead the eye through the design, as in example C. (A single colored dot adds additional interest.) When the value of the illustration is low-key, the one colored dot takes on a new emphasis (example D). Using the six primary and secondary colors, it's possible to divide the design by placing warm colors with warm colors and cool colors with cool (example E). When warm dots are placed over cool squares, as in example F, the design takes on renewed interest. By transitioning warm colors to cool colors, it's possible to create an interesting blend of color (example G). Notice the contrast that is achieved in example H by placing one warm dot on a background of cool dots and squares. Example I shows another random design created through the use of color.

This menu is designed using all warm tones. Warm tones consist of any color on the warm side of the spectrum: yellows, reds, oranges and purples. The effect is great for a menu because it communicates a comfortable feeling and a compatibility with food. Could you imagine this same menu done in cool tones: blues and greens? The effect would be completely different. It is no coincidence that most fast-food restaurants use yellows and reds for their identities. These colors have been shown to be among the most appetizing.

Black Cat Menu
Dennis Clouse
Cyclone Design

This beautifully colored annual report uses photographic duotones, each a mixture of black and one of seven PMS colors, then printed on frosted acetate. These translucent photo pages then overlay pages of large text reversed out of compatible solid PMS colors. Although there is no use of four-color process, the duotones combined with the solid colors give the design a very lively look. Because these duotones use saturated color, they are fairly low-key (darker in tone), which creates an intriguing contrast against the white of the paper on opposite pages. Additional contrast is provided by the use of small serif text type on the white pages and large sans serif type on the color pages. The design readily communicates the environmental concerns of the company through photographs of natural landscapes. While the photography is splendid, the bright solid colors add additional snap to the design. These colors aren't at all earth tones, which might be the expected solution; instead, they are vibrant, saturated colors that draw the eye to the key messages printed on them.

Earth Technology Annual Report

Lana Rigsby

Rigsby Design

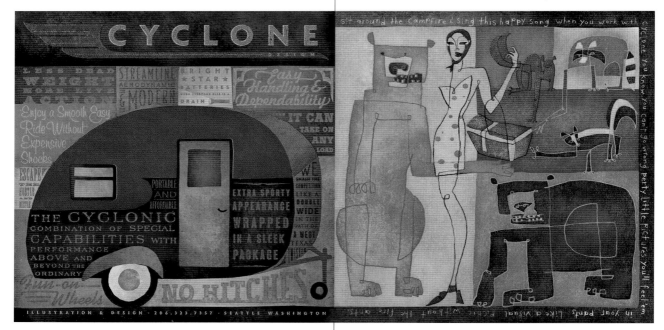

These two posters are not only good examples of color and value but are unified in their appearance without looking too much the same. They are also appropriate examples of how proper use of texture can enhance a design. But first, let's look at color and value. The bottom poster uses primarily grays, reds and oranges. While there is a predominance gray, it is a warm gray, so the values are similar. However, because of the presence of the red, it is not quite monochromatic. It would be fair to say, by virtue of the absence of any pure whites, that it is also fairly low-key in value. The top poster is much more colorful but still falls within the same low-key range of value. Because of the color palette, it does not run the risk of being anywhere near monochromatic. Both posters use type as a texture.

Cyclone Self Promotion

Dennis Clouse, Traci Daberko

Cyclone Design

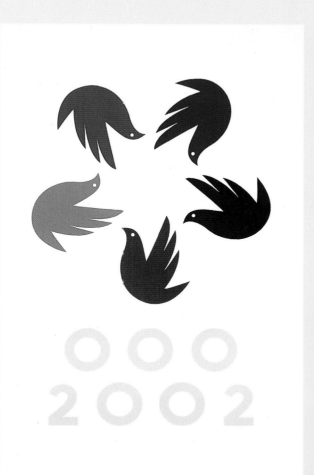

Olympic Colored Doves Poster
McRay Magleby
Magleby and Company

Olympic Colored Doves Poster
McRay Magleby
Magleby and Company

This poster would be a candidate to appear in either this chapter or in the shape chapter of this book. I elected to place it in this section because the colors carry it to a level that goes beyond the clever design configuration of the shapes. The meaning of this poster is open to interpretation from the viewer. I immediately interpreted the colors to signify the peaceful coming together of different nations and ethnic groups for the Olympic games. Another might view it differently. That said, for me the concept lies in the colors. It would have been a mistake to use anything but the entire spectrum of colors since it is not necessary to literally interpret the different ethnicities of the world. In fact, this selection of colors makes the poster much more appealing. Notice the implied star shape that the doves create.

In a more corporate vein is the Oracle Mobile identity. This sophisticated look is due to the smart color palette made available for the different pieces. Although simple in its design, this look is at once conservative and fresh. Often designers become discouraged when the client seems bent on the idea of portraying the company in a conservative way. However, every problem can have an interesting solution. The trick is to think of a solution that uses the conservative confines of the assignment as assets instead of liabilities. This project does exactly that.

Oracle Mobile Identity
Brian Gunderson
Templin Brink Design

Staying true to the color palette is, once again, partially responsible for the success of this series of pieces. The designer has worked within the range of one typeface to make the design even more appealing. Using a common style of illustration is yet another key to the unity of these pieces. But beyond those three common elements there is a world of variety among these pieces. Most impressive, however, is the use of color. The designer and illustrator were in sync when it came to establishing a color palette that would work handsomely for both the design and the illustration. Contrasting with the yellow book covers are solid gray, black and blue cases. Each of these cases gives way to the solid yellow cover once the piece is opened.

The NSBU Bright Book
Gaby Brink
Templin Brink Design

This brochure is a perfect example of a low-key monochromatic design. The metallic copper color is dominant throughout. The only highlights are an occasional white image floated onto the layout: a rose, a feather, a wing, a key—all done in minimal detail. Another successful facet of this book is the use of a gloss spot varnish for the cover type over the solid dull varnish of the rest of the cover. Because the general tone of the book is so even, this type is discovered only after close inspection and by holding the book at different angles. Texture is at work through the entire piece, bringing a nice variety to the pages. The textures themselves are photographs of brushstrokes, roses, water, a curtain and other surfaces. These all work in concert with a calligraphic typeface to create a subtle look that is full of impact.

Book of Be Brochure

Miler Hung

Peterson & Company

Color & Value

It is entirely possible to influence the tonal value of a book through the strategic use of photography. When a designer assigns photography for an annual report such as this one, there is usually a meeting where the look and tone of the book is discussed. That way the designer and the photographer are on the same page as to the visual intent of piece. In the case of this annual report, the photographer was assigned to shoot the book in high key; that is, the tone of the photos should be more light than dark. As you can see, the photos have almost a bright glow for a background and most of the subjects are shot against a backdrop of white. This is complimented by a design that lets the type sit on a predominantly white page. The overall effect is that the photos melt into the design and the typography and photography are seen almost as one element.

Weyerhaeuser Company Annual Report

Lana Rigsby

Rigsby Design

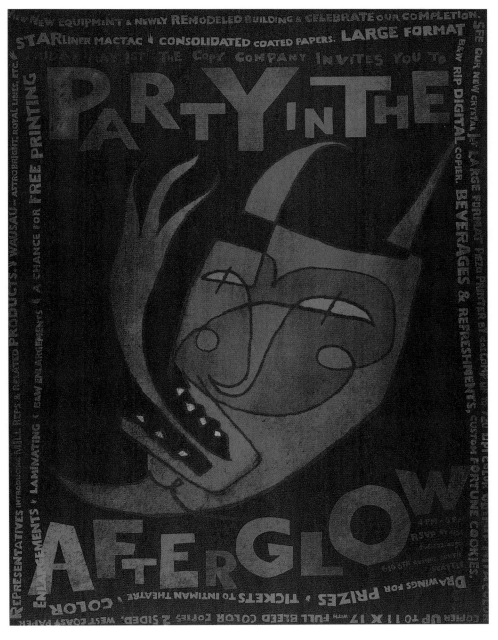

Party in the Afterglow Poster
Dennis Clouse, Traci Daberko
Cyclone Design

This poster is an example of monochromatic color. Monochromatic means it consists of one tone of color. Even though the poster has subtle shades of orange, red and even yellow in the teeth, it is predominantly one tone of color. This is also an example of a low-key color scheme. Remember, low-key refers to the overall value of the piece. In this case, it is fairly dark—predominantly darker than 50 percent black and, thus low-key. Given the concept of the poster, to go this way was a good decision by the designer. The irregular type on this poster is also interesting and appropriate to the subject matter.

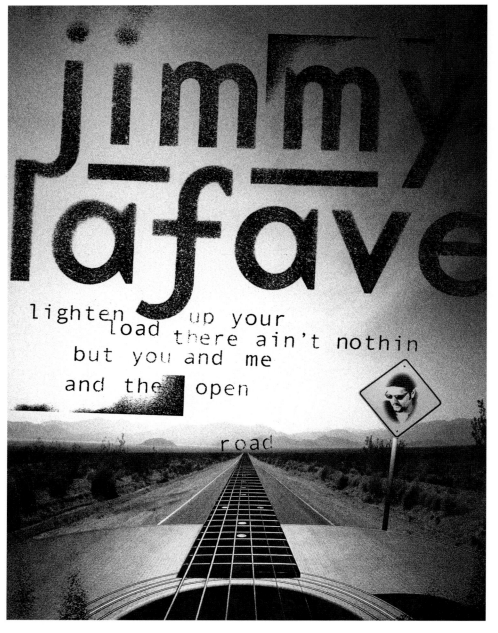

Jimmy LaFave Poster
Bryan Peterson
Peterson & Company

This poster is another example of a nearly mono-chromatic poster. Most of the tones of the predominant elements in the poster are warm tones, including those in the sky, guitar and road sign. Consider repeating colors in different elements as a way of unifying your design. It is no coincidence that the same fiery blend of color in the sunset sky is repeated in the guitar and, to a lesser extent, in the road sign. Notice how the guitar brings the eye into the bottom of the poster and points the viewer to the name and copy. The guitar was shot with a digital camera and elongated using the perspective tool in Adobe Photoshop. The concept of the poster is to equate the neck of a guitar with the idea of being on the road to freedom.

I included this piece for several reasons. Not only is the design simple and elegant, but it also provides an excellent example of a great contrast in values used effectively; darker-valued full-page photographs work well with lighter-valued text pages. Each of the shots (including the photograph of the officers) uses the same painted canvas background, which instantly unifies the design and enhances the mood. The suitcoats and suitcoat hangers, used as props in nearly every photo, are unifying elements that serve to tie all the photo pages together. The text pages are handled simply and consist of just two ink colors (brown and green) printed on a cream-color stock. These type colors are compatible with the photo pages because they're pulled from tones in the photography. The suitcoat props are one of the most interesting aspects of the book. Each of the coats was created to illustrate an idea, such as "Global Competitors" and "Executive Resources." This concept is carried effectively throughout the design through similar treatment of one important idea on each spread. Attention is given to even the smallest details to reinforce the concept, and anything that might detract from the concept is removed.

UIS, Inc. Brochure

Tim Sauer

Agency Eleven (formerly The Kuester Group)

Ask Yourself These Questions...

FORMAT

What visual impact do you want this piece to have on the intended audience?

How much information will you eventually place on the format?

Does the quantity of type or quality of art dictate that you use a certain proportion?

How will the desired format print on standard paper sheet sizes?

Will using a smaller size or a different format give you a break on mailing costs?

What is the visual function of the piece?

LINE

Have you chosen lines that convey an appropriate mood or strengthen your idea in some way?

Have you given thought to the full array of possible types of line you might use?

Are you using line to connect or separate other elements on the page?

Do the lines actually lead your eye in the ways you intend?

Does your use of line create texture in your design or illustration?

Are there lines in your design that are freeloading on the design—not performing a service of any kind?

TYPE

What typestyle will best communicate the feeling of your message?

Does your typeface harmonize with or detract from your message?

Will two or more different typestyles be more effective in displaying the concept than one?

Is the type size appropriate for the audience?

Is the type properly placed in the format to have the most impact on the reader?

Are the shapes of the body copy pleasing or are they unattractive?

Is the typeface one that needs to hold up well over a period of time, or is a more current typeface a better choice?

SHAPE

What kinds of shape will be most appropriate to your concept?

Will you use photographs? Illustrations? Shaded areas?

Will shapes be used to break up blocks of text or to unify other elements?

Does it make sense to break your text up into different shapes in order to improve the communication of your message?

When you look at your design, where does your eye go first?

Have you successfully removed any shapes that detract from the idea of the design?

TEXTURE

Will an overall texture help to convey the idea of your design?

Have you considered using the textures that surround you in everyday life?

Even if texture is not to be added graphically to your design, what role will be played by the texture of the paper you use?

Will you use artwork, in the form of a photograph or illustration, that conveys a feeling of texture?

Do the textures you've chosen to use support or overwhelm the concept of your piece?

BALANCE

Does your concept call for symmetrical balance or asymmetrical balance?

Does your design need a purposely unbalanced look?

What elements will you use to achieve balance?

Will you balance elements that are similar to one another or elements that are different?

What are the different moods you can create with the balance in your design?

Have you let your art and concept dictate the needs of your design in terms of balance?

CONTRAST

Do the contrasts you've chosen for your design strengthen its idea?

Have you fully considered all the ways you might achieve contrast?

Do you want to use contrast in value or color? Shape? Texture? Typography?

Are your choices of contrast in typography suitable to the message of the design?

Have you pushed contrast to its most obvious level?

Have you considered the idea of diminished contrast?

UNITY

Does the design you want to do call for a grid?

How complex will your grid need to be?

What elements will be consistently placed according to the grid lines?

Where might it benefit your design to break the grid?

When you look at pages where you've broken your grid, do they still seem connected to the pages where your grid is intact?

Have you been able to achieve unity through the use of similar elements?

Have you eliminated any elements that distract the eye and pull it away from important parts of your design?

VALUE

Have you really chosen the values present in your design?

Have you intentionally chosen values that provide contrast?

Have you intentionally chosen values that are very similar to provide a subtle, or blended, effect?

Does value help move the eye through your design?

COLOR

Do the values in your design work, or is color being used to "save" a poorly conceptualized design?

Would a predominantly cool color scheme be enlivened with warm accents (or vice versa)?

Have you considered an appropriate use of neutral colors in your design?

Would your design work better with the full brightness of color, with grayed tones or with pastel tones?

Would your design be more visually pleasing by using color sparingly, as sharp accents?

Do you have a design that would actually work best in black and white?

Contributors & Permissions

CONTRIBUTORS:

Agency Eleven
10000 Highway 55
Minneapolis, MN 55441
www.agencyeleven.com

Cronan Design
1500 Park Ave., Ste. 422
Emeryville, CA 94608
www.cronan.com

Cyclone Design
1517 12th Ave.
Seattle, WA 98122
www.cyclone-design.com

Fossil
2280 N. Greenville Ave.
Richardson, TX 75082
www.fossil.com

Greteman Group
1425 E. Douglas, 2nd Floor
Wichita, KS 67211
www.gretemangroup.com

Haley Johnson Design Co.
3107 E. 42nd St.
Minneapolis, MN 55406

Magleby and Company
226 S. 1920 W.
Provo, UT 84601

Pattee Design, Inc.
138 Fifth Street
Des Moines, IA 50265
www.patteedesign.com

Peterson & Company
2200 N. Lamar, Ste. 310
Dallas, TX 75202
www.peterson.com

Rigsby Design
2309 University Blvd.
Houston, TX 77005
www.rigsbydesign.com

Sommese Design
100 Rose Dr.
Port Matilda, PA 16870
www.sva.psu.edu

Templin Brink Design
720 Tehama St.
San Francisco, CA 94103
www.templinbrinkdesign.com

The Office of Eric Madsen
123 North 3rd St., Ste. 600
Minneapolis, MN 55401
www.emadsen.com

Vaughn Wedeen Creative
407 Rio Grande NW
Albuquerque, NM 87104
www.vwc.com

Vrontikis Design Office
2707 Westwood Blvd.
Los Angeles, CA 90064
www.35k.com

Werner Design Werks, Inc.
411 1st Ave. N #206
Minneapolis, MN 55401
www.wdw.com

PERMISSIONS:

Agency Eleven
Page 139© The Kuester Group/Agency Eleven

Blue Q
Page 63© Blue Q

Cronan Design
Page 65© Cronan Design

Cyclone Design
Pages 43, 49, 58, 72, 73, 87, 103, 117, 130, 132, 137© Cyclone Design, Inc. 2002. All rights reserved.

Fossil Design
Pages 76, 121© Fossil Design

Greteman Group
Page 89© Greteman Group

Haley Johnson

Pages 29, 36, 51, 62, 75© Haley Johnson Design Co.

Magleby and Company
Pages 30, 32, 33, 64, 89, 90, 100, 133© Magleby and Company

Pattee Design
Pages 47, 79© Pattee Design

Peterson & Company
Pages 31, 46, 48, 60, 66, 77, 92, 93, 104, 105, 106, 120, 135, 138© 2002 Peterson & Company

Rigsby Design
Pages 59, 74, 88, 101, 107, 119, 131, 136© Rigsby Design, Inc./Houston, TX

Sommese Design
Pages 28, 34, 45, 52© Lanny Sommese

Target
Page 116© Target Corporation

Templin Brink Design
Pages 35, 44, 50, 64, 71, 78, 93, 115, 116, 133, 134© 2002 Templin Brink Design LLC

Terry Vine
Page 74© Terry Vine, Photographer

The Office of Eric Madsen
Page 48© The Office of Eric Madsen

The Van Dyke Company
Page 61© The Van Dyke Company

Vaughn Wedeen Creative
Page 118© Vaughn Wedeen Creative

Vrontikis Design Office
Page 102© Vrontikis Design Office

Werner Design Werks
Pages 46, 63, 108, 122© Werner Design Werks, Inc.

Index

Index

More advice, ideas and inspiration from HOW Design Books!

Inspiration is key to your success as a designer. It makes you more creative, energetic and competitive. Unfortunately, inspiration doesn't always come when and where you want it. *Idea Revolution* includes 120 activities, exercises and anecdotes that will jolt you, your colleagues and your clients back to creative life. You'll find unique, motivational solutions to virtually every graphic challenge.

ISBN 1-58180-332-X, paperback, 160 pages, #32300-K

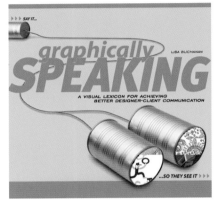

Graphically Speaking breaks down designer-client dialogue into something both parties can understand. It details 31 buzzwords (such as "innovative" or "kinetic") related to the most-requested design styles. Each entry is defined both literally and graphically with designer commentary and visual reference materials, ensuring clear designer-client communication every time!

ISBN 1-58180-291-9, hardcover, 240 pages, #32168-K

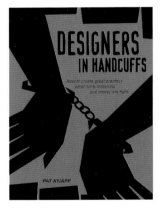

These books and other fine HOW Design titles are available from your local bookstore or online supplier, or by calling 1-800-289-0963.

Turn an impossible deadline into a realistic schedule. Identify problem areas before you start working. Master software and production techniques that save time and money. Produce good design on even the tightest budget. In *Designers in Handcuffs*, Pat Matson Knapp shows you how to do all this and more to beat project constraints and create head-turning designs every time.

ISBN 1-58180-331-1, hardcover, 192 pages, #32297-K

To keep your work fresh, you've got to look beyond the usual borders of graphic design and into other artistic fields. Inside *The Art of Design* you'll find hundreds of dynamic designs inspired by everything from Academy Award-winners to watercolor classics. Captions and sidebars reveal how each piece was developed and offer hundreds of creative suggestions to help inspire your own unique work.

ISBN 1-58180-337-0, hardcover, 144 pages, #32305-K